About the Author

Prof. Paul Vogt has been the Director of the Folkwang Museum in Essen for several years. His numerous publications on modern art include: *Christian Rohlfs — Aquarelle und Zeichnungen* (Recklinghausen, 1958); *Christian Rohlfs — Das graphische Werk* (Recklinghausen, 1959); *Erich Heckel* (Recklinghausen, 1959); *Farbige Graphik der Gegenwart* (Recklinghausen, 1959); *(Standplastiken aus Stahl* (Düsseldorf, 1961); *Leuchter und Lampen aus Stahl* (Düsseldorf, 1963); *Das Museum Folkwang in Essen* (Dumont, 1965); *Christian Rohlfs* (Dumont, 1966); *Was sie liebten — Salonmalerei im 19. Jahrhundert* (Dumont, 1967); *Geschichte der deutschen Malerei im 20. Jahrhundert* (Dumont, 1972 and 1976).

ALMA=NACH DER BLAUE REITER

R. PIPER & Cⁿ MÜNCHEN VERLAG

The Blue Rider

Author: Paul Vogt
Translator: Joachim Neugroschel

Woodbury, N.Y.

Barron's
London

Front cover illustration: Gabriele Münter, Courtyard with Laundry, 1909
 (Color Plate 3)

Back cover illustration: August Macke, Lady in Green Jacket, 1913
 (Color Plate 16)

Frontispiece illustration: Vassily Kandinsky, final draft for the cover
 of *The Blue Rider* almanac. 1911

All inquiries should be addressed to:
Barron's Educational Series, Inc.
113 Crossways Park Drive
Woodbury, New York 11797

N
L868.5
.E9
V6313

Library of Congress Catalog Card No. 80-341
International Standard Book no. 0-8120-2100-2

Library of Congress Cataloging in Publication Data

Vogt, Paul, 1926-
 The Blue Rider

 Translation of Der Blaue Reiter.
 Bibliography: p.
 1. Blauer Reiter. 2. Expressionism (Art) —
Germany. 3. Art, Modern — 20th Century — Germany.
I. Title.
N6868.5.E9V6313 759.3 80-341
ISBN 0-8120-2100-2

PRINTED IN THE UNITED STATES OF AMERICA

CONTENTS

Preface

In 1912, R. Piper Verlag published the first edition of *The Blue Rider* in Munich. This collection was probably the "most important programmatic book of twentieth-century art" (Lankheit), and a literary source of unusual documentary value. More than sixty years have elapsed since its first appearance. Not every artistic utterance is as topical now as it was then; but that does not detract from the significance this volume has for the art of our century. The book mirrors the fruitful spiritual and intellectual ferment of the period before World War I — with its faith in the future, its artistic conviction, its ideas of a European scope with lines of influence between East and West crossing in Munich. In their bold style and daring conception, though perhaps not in their revolutionary attitude, the editorial statements of *The Blue Rider* far surpass the laconic manifestos of *Die Brücke ("The Bridge")*, which had begun to flourish in Berlin at that time.

The new documentary edition of *The Blue Rider* in 1965, the publications of Munich's Städtische Galerie (custodian of a vast legacy of originals and archives), and a series of studies on the artists involved in the Blue Rider, have all recently brought to light a wealth of new material. This refutes the frequently heard opinion that there are "no documents about the days when the now famous volume was taking shape." The painters and the very concept of the Blue Rider are well known not only in Germany. But the fame and importance of this movement often make people forget that this was not a group of artists like Dresden's *Brücke*; it was an editorial board consisting of only two painters, Franz Marc and Vassily Kandinsky. The way problems were posed and the goals that were

set up clearly reveal the artistic notions of the two friends, who also involved a number of other like-minded artists in their notions. They tried to formulate ideas that still had to be solved in pictorial practice. They discussed the consequences of those ideas, comparing them with other times, countries, and areas, in order to strike a balance for the future.

The reciprocal feedback between a theoretical foundation and practical experience, the participation of major personalities in theory, fine art, and music, all increased the significance of these studies. Later generations could draw from a source that is still unexhausted today.

In order to provide a better understanding of this artistic phenomenon, the present book includes the preliminary stages of the years 1900-1912, a time of upheaval and preparation, from *Jugendstil* and nature lyricism to the end of the *Neue Künstlervereinigung* (the New Artists' Association) in Munich.

This book is not meant as a scholarly commentary on previous publications. By using newly revealed sources, this study intends to present a picture of those years of upheaval that led to the problems of the new century, the problems of "absolute (abstract) painting" (Kandinsky). The outbreak of World War I aborted the beginnings of this movement. It scattered the friends, but it did not paralyze the impulses, as we know from the distance of time.

A documentary appendix quotes the sources of those years insofar as they relate to the text and are not readily accessible to the interested reader. Further information can be found in the bibliography, which goes up to 1975 but is limited to the most essential publications.

Essen, April 1976 Paul Vogt

1 Franz Marc around 1913

Vassily Kandinsky in Munich. 1913

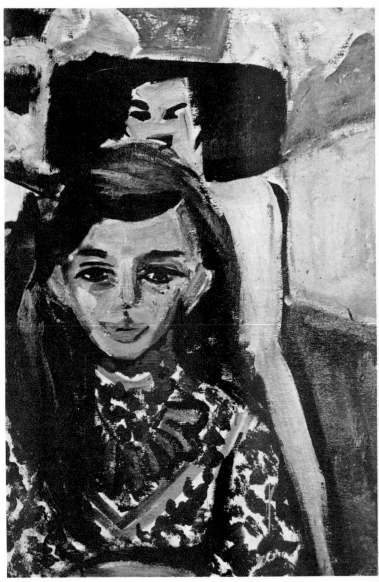

3 Ernst Ludwig Kirchner, *Fränzi in front of Carved Chair*. 1910

Historical Background

The crisis in European art that had emerged during the late nineteenth century became more intense around 1904/05. A revolution-minded generation of artists started out amid a ferment caused by forerunners like Van Gogh and Gauguin, Munch and Ensor, with their critique of Impressionism's view of life. Impressionism had been the last "great style" in which the reality of the visible world had once again brilliantly manifested itself. This style had been in unquestioning agreement with the external world, which it recognized as the basis of reality, esthetically heightening it and happily mirroring it in the paintings of Monet and Renoir, Sisley and Pissarro. But now a sudden skepticism emerged regarding that style, and people began to question the true kinship between the self and the world. Faith in the reality of visual impressions and sensual perception as the basis of the artist's optimistic relationship to nature were now abruptly challenged. More important than the outer appearance of things were the feelings they aroused. The artist's gaze was turned inward. His goal was no longer to reproduce nature, but to represent it in art. The artist's job was to examine, expose, and confirm the permanent tension between the inner and the outer worlds. His task was no longer to *depict* the visible, but to *make* visible, as Paul Klee so cogently put it.

This new perspective determined the work of painters in both France and Germany. However, the definition of the common term "expression" (symbolizing the attempt to superimpose the expression of personal feelings upon reality and thereby to abstract it) was ultimately not binding for both countries. German artists were more interested in the idea than the artistic form, and the intellectual conception seemed more important than the picture.

1

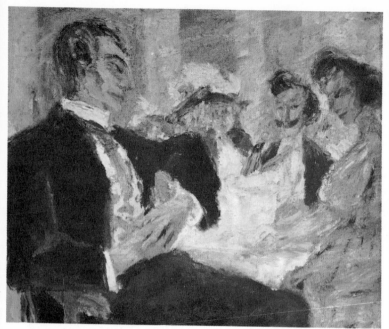

4 Emil Nolde, *In the Café*. 1911

The illusory world of objectivity was opposed by the vision of a more comprehensive truth, the "universe of the interior." The "distortion of nature," as the process of conversion was called, was taken as a metaphysical rather than a formal necessity. "Instinct is worth ten times more than knowledge," said Emil Nolde on behalf of his fellow battlers. Like him, they were convinced that the sole function of the work of art was to express a powerful sense of life and to interpret the concepts of "man" and "reality." This attitude led to an aloofness from nature and an end to description. Instead, painters sought the "great secret" to which the reality of visible being must subordinate itself to keep from blocking the artist's path to the heart of things.

The public barely took heed of these incipient changes. In their eyes, the Fauves, the Expressionists, and their ilk were esoterics or

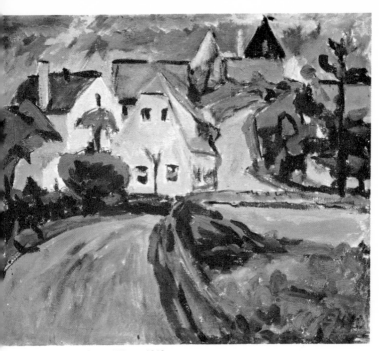

5 Erich Heckel, *Saxon Village*. 1910

iconoclasts. The notion of a threatening "degeneration" of art arose in Berlin long before the Nazi regime came to power. Exhibits by young artists were rejected, or at best ridiculed. In Germany, unlike France, the decisive impulses did not come from the capital. At that time in the German metropolis, *plein air* painting was gaining acceptance, although not on all sides, as the newest trend, with the leaders of the "Berlin Secession," which had split away from academic tendencies after the Munich commotion. Corinth, Liebermann, and Slevogt, fought by traditionalists as followers of French Impressionism, were seen by the public as advocating a revolutionary position — which was really long since passé. Their growing renown, however, blocked the path of the new generation, whose representatives lived as loners or, like the Dresden *Brücke,* as a group of friends in the provinces.

3

In 1910/1911, however, the *Brücke* moved to the German capital. This marked the beginning of decisive conflicts and the final breakthrough of northern and central German Expressionism. Its character was shaped by the lively and demanding intellectual climate of Berlin and the tensions of the last few years before the war. Even a lone wolf like Nolde was struck by some of the repercussions. His famous attack on Max Liebermann sharply characterizes the incompatability of the two artistic positions, with Expressionism ultimately carrying the day. Berlin became the center of the Expressionist revolution.

In southern Germany, the younger artists gathered in and around Munich. Their goals and arguments were akin to those of the northern and central German painters, but their development took a different course. Local traditions endured for a long time. Moreover, there was a perceptible influence of foreign artists. Early on, people could visit shows of contemporary French art in Munich. East European ideas flowed in through the small colony of Russian artists who had established themselves there since the late nineteenth century. They, above all, were to leave an unmistakable impression on the southern German scene. Munich artists knew little of the Expressionists. At best there were loose contacts with Pechstein. It was Franz Marc who, by visiting Berlin in the winter of 1911/12, first created ties with the Expressionists. Yet these ties were not very strong, and they could not clear up a final lack of understanding, for example in Kandinsky.

In Munich, along with the symbolistic tendencies of German nature lyricism, it was mainly the ideas of *Jugendstil* that motivated the young painters and turned their gaze in a specific direction. In the late nineteenth century, devotees of nature lyricism, at home in landscape-bound schools like Dachau in the south or Worpswede in the north, had so extensively reshaped and stylized nature that it evoked moods and feelings. They had wrung expressive effects particularly from color. In this light, it was quite consistent of the young Nolde to head for Dachau when Stuck wouldn't take him into his Munich studio.

The *Jugendstil* arguments partly overlapped with those of nature lyricism. But their scope was much broader. Their formal, esthetic conception was based essentially on the elements of plane and line. Their point of departure was the stylized natural form, which, being recast, offered new formal possibilities. Graphic lines became

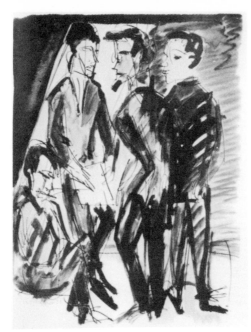

6 Ernst Ludwig Kirchner, *The Painters of the Brücke*. 1925 (from left to right: Mueller, Kirchner, Schmidt-Rottluff, Heckel)

7 Fritz Erler, *Horses by the Brook*

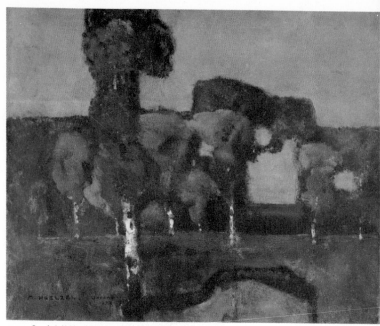

8 Adolf Hoelzel, *Landscape with Birches*. 1902

a floral ornament with an extraordinary decorative effect. At the
same time, however, the line, fundamental to the ornament,
turned out to be trend-setting when it was seen not as designating
form but as an abstract element of shaping. "A line," said the
Belgian architect Henry van de Velde, "is a force; it takes its
strength from the energy of the artist who drew it." He thus
articulated the insight so momentous for the southern German
situation: namely, that images of nature can be replaced by abstract
forms as communication signs of a more comprehensive character.
The conviction of the "power of pure form on the human mind,"
the notion that there are lines and colors "virtually containing the
forms of reality, metaphysically more real than those feeble
reflections of being that are adjusted to cerebral perception" —
thoughts that in Munich were formulated by the people attached to
the journals *Pan* and *Jugend*, indicated the direction of the Blue

6

Rider at an early stage. It basically took only a small but decisive impulse to liberate nonobjective form from its overgrowth by an arts-and-crafts decor and make it serviceable to the artist.

Painters also realized the emotional effect of color. Here again their goal was no longer the object, but the expression. The artist was busy wondering "how to create totally pure plane backgrounds in which a lost music of colors and forms floated" (O. Bie).

Such ideas, needless to say, found only gradual acceptance. Conflicts about these new ideas were as violent in Munich as they were in Berlin. "In no German city did the old and the new clash so violently as in Munich," Corinth later recalled. The new movements found a mouthpiece in two satirical, anti-clerical, and anti-academic magazines launched in 1896: *Simplicissimus* and *Jugend*, whose editorial boards advocated independent artistic creation. They tried to heed and promote all new trends, and not just *Jugendstil,* as one might assume from the name of the latter. Four years earlier, younger artists had banded together against the traditional forces for the (first German) "New Secession." They principally wanted to attain better exhibiting conditions for independent artists from the Munich *Künstlergenossenschaft* (Artists' League), which was dominated by Lenbach. In 1899, artists affiliated with the above-mentioned magazines founded as association to express their solidarity. That same year, the germ cell of this "youth group" brought forth the Artists' Association *"Scholle."* The fact that most of its members were also associated with the magazine *Jugend* meant little in terms of a uniform style. Instead, the old problems inherent in such locally inspired groups re-emerged: form fought against emotion, nature against style. Nonetheless, the previously mentioned ornamental tendencies united with nature lyricism to produce mood works that aroused emotions. The artists' formal vocabulary remained simple: white birches in front of dark moors, cringing huts, roads melting into twilight. The evocative power of colors was more persistent. It evoked the melancholy delight unknown to academic realism, it indicated the artist's willingness to harken to the inner life of nature and respond to it. But the *"Scholle"* artists did not risk a revolutionary style; the esthetic notions of the bourgeois era prevailed.

In essence, the "New Dachau" group of painters, founded in 1894, was akin to the *"Scholle."* In the new group too, painters

went beyond the acquired academic conception to the primordial state of the landscape. A more distinct aspect, however, was the sense of a common mission which grew out of the artists' somewhat melancholy relationship to nature. Although stylization was an almost self-evident commandment, only one artist went all the way with one facet: "When meditating on something or being absorbed in a mood, one has the habit of thinking the inner rhythmical process through by drawing lines on paper." It was Adolf Hoelzel who, even before Kandinsky, crossed the border to abstraction. Simplifying form, concentrating on compositional dynamics that are important to the picture, rhythmically articulating planes, judging color according to its decorative value — these things all point to artistic demands "that are no longer derived from nature in the usual sense. That brings us to the question of the notion of the picture." In this case, too, *Jugendstil* was a direct preliminary stage in the quest for the motive forces of nature and art. However, Hoelzel had left the Munich scene by 1906, just when the decisive transformations were starting.

At this point another artistic personality stepped into the middle of this trend: Vassily Kandinsky, born in Russia and living in Munich since 1896.

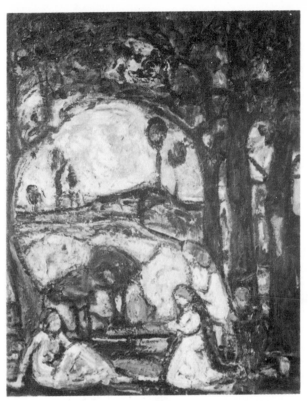

9 Adolf Hoelzel, *Belgian Motif.* ca. 1908-10

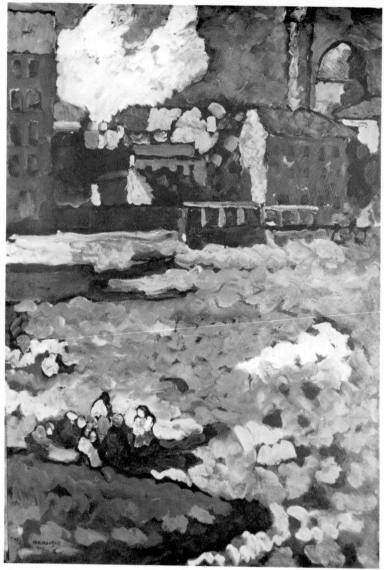

10 Vassily Kandinsky, *Outside the City*. 1908

The Background of the Blue Rider

Before World War I, Moscow had visibly developed into the bastion of abstract trends. Impulses came from the West: Symbolism, Fauvism, Cubism, Futurism. And these were all promptly reinterpreted by young artists into abstract terms — based on something that is deeply rooted in the Russian mentality: a willingness to recognize the higher reality in a sensory sign. East European mysticism and the sign language of Russian icons had helped to pave the way. Thus it was no accident that the Russian influence in Munich was able to provide a last step towards putting abstract art into practice after it had been fully developed in theory.

When Kandinsky had seen Monet's haystack paintings at a Moscow show of Impressionists, he had wondered whether the power of pure colors might not be an incomparably greater artistic reality than the object itself. This idea not only kept occupying his mind, it became the strongest mainspring of his artistic work after he moved to Munich. A distinctly synesthetic gift supported this trend, in keeping with topics that had been discussed in Europe since the nineteenth century: concepts of an association between color and musical sound. Endell, a *Jugendstil* artist in Munich, thought of a "formal art operating by means of freely found forms, the way music operates through free tones." This notion had to affect the sensitivity of the Russian artist, who, upon hearing Wagnerian music as a student, had noted: "I could see all my colors; I realized that painting has the same power as music." And there was something else. The findings of contemporary science bore out what the young artists were doing. When Max Planck founded quantum theory in 1900, he changed prevailing ideas, not only on physics but on the general view of nature. Einstein's theory of relativity, his law of the equation of mass and energy, opening

11 Vassily Kandinsky, *Bright Air*. 1902

the way to atomic research, was published not much later. Nuclear
fission and the space–time continuum were also grasped by artists
as notions toppling earlier conceptions. The universe expanded
beyond seemingly solid limits into immeasurable smallness and
largeness, but also into the nonvisible, for which new sensory signs
had to be found. Kandinsky expressly emphasized how important
this scientific confirmation was for the desired goal of detachment
from the object. Because now "one of the weightiest obstacles on
the road to the fulfillment of my dreams has dissolved and vanished
on its own." "Future art," noted Franz Marc, "will be the formal
realization of our scientific conviction." It was the artist's duty to
make the expanded Creation visible in his way and with his means.

In 1901, Kandinsky founded "Phalanx," a school of painting
and a group of artists in Munich. This was an attempt to transmit
his insights to like-minded people, thus creating a crystallization
point. But despite a number of shows devoted to the most recent
European modernism, the influence of "Phalanx" was not enough
to create a strong foundation for the envisioned base of international

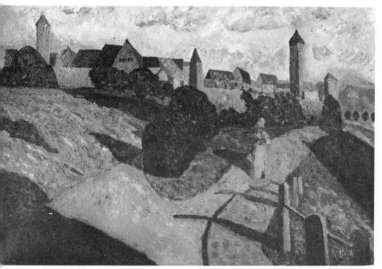

12 Vassily Kandinsky, *Old Town* (Rothenburg on the Tauber). 1902

young art. The lack of a clear concept, of a well-grounded deliberation, and of like-minded fellow strugglers, had terminated the enterprise by 1904.

In the following years, Kandinsky concentrated on Paris. As a member of the Salon d'Automne and the Indépendants, he came under the influence of the Fauves. His dealings with the French development clarified his own situation and pointed in a different direction. Kandinsky's colorful fairy-tale world, a blend of Russian folklore and late Impressionism, was gradually replaced by strongly colored compositions fairly removed from optical impression. But despite their east European character, they showed a more independent use of color.

When the painter returned to Munich in 1908, he went back to his old thoughts about the musical value of color. But he was now better equipped to focus on that. He understood that the motif becomes less important when the content of a painting can be expressed by the symbolic and emotional possibilities of color. At this point, the slow withdrawal of the object and the growing

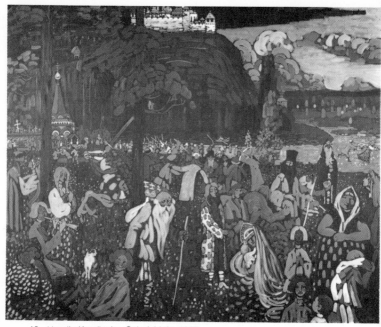

13 Vassily Kandinsky, *Colorful Life*. 1907

independence of color and form in no way indicated a decision for abstractness. The latter remained the furthest possible goal. Thus Kandinsky's *First Abstract Water Color* of 1910 (ill. 16) is more a sign of the exploration of limits than the final point of an artistic development which was still mainly determined by objectivity. Kandinsky wrote a text during this period, *On the Spiritual in Art,* which clarifies this tension-fraught situation. But it does not omit "external nature" as the source of "vibrations" for the artist.

Knowing the goal theoretically but being unable to achieve it artistically — that was what characterized the situation at this time. The quest for suitable connections between the inner and the outer world challenged the intellect and demanded discussions with congenial artists. The group closest to Kandinsky included: the Russian Alexej von Jawlensky, who was also under the spell of

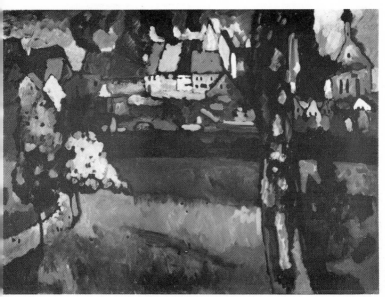

14 Vassily Kandinsky, *Upper Bavarian Small Town* (Murnau). 1909

French art; Marianne von Werefkin, who had come to Munich with
Jawlensky in 1897; and Gabriele Münter, a member of "Phalanx"
since 1902 and Kandinsky's companion. These people may have
brought up the idea of an association of artists as a reservoir of the
avant-garde. Thus, on January 22, 1909, the *New Artists'
Association* was launched. On March 23 of that year it was legally
registered in Munich. Other founding members were: Adolf
Erbslöh, born in New York and living in Munich since 1904;
Alexander Kanoldt, who was born in Karlsruhe and had settled in
Munich in 1908; the draftsman and writer Alfred Kubin, who had
been introduced to Kandinsky through his novel *The Other Side*
(published in 1908); and the art theoreticians Dr. Heinrich
Schnabel and Dr. Oskar Wittenstein.

During the first year of the enterprise, they were joined by: the
German neo-impressionist Paul Baum; the former Russian officer
and painter Vladimir von Bechtejeff; the painters Erma Barrera-

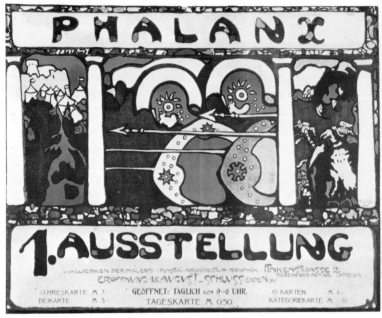

15 Poster for the first Phalanx exhibit, 1901

Bossi and Carl Hofer; the sculptor and medallist Moissey Kogan; and the dancer and set-designer Alexander Sacharoff.

This association, which was different from the usual artistic alliances, was probably rooted in Kandinsky's notions: "Aside from this union of different countries for one purpose, which we regarded as the highest, there was one thing that was new at this time: along with painters and sculptors, we also took in musicians, poets, dancers, and art theoreticians. That is, we sought to unite individual phenomena into 'one.' " These words hint at ideas that took solid shape only later, in the Blue Rider. On the other hand, the diversity of attitudes and convictions and the differences in quality contained the seeds of great controversies. Kandinsky's bold conclusions, which now began taking pictorial form, were sure to arouse protests, especially among the lesser talents.

16

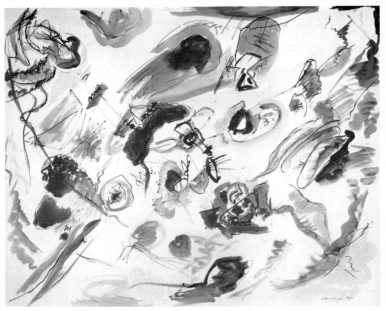

16 Vassily Kandinsky, *First Abstract Water Color*. 1910

The first circular of the *New Artists' Association* sounds both
hopeful and compromising. It says that artistic synthesis is the
watchword of the hour and can be based on both external
impressions and the experience of the "internal world." The later
member Otto Fischer, an art historian, stressed the necessary
"solidarity of inner conviction." Exhibits were to make the
connection with the public. They had to include works created
"with a view towards the new goal" — a short-lived hope, as it
soon turned out. In December 1909, the first show opened in the
"H. Thannhauser Modern Gallery." "Heinrich Thannhauser had
what were perhaps the loveliest rooms for exhibiting in all Munich.
and Tschudi (H. von Tschudi, general director of the Bavarian
Museums) got the space from him. . . ." (Kandinsky). Statutes
provided that each member was free to show two paintings without

17

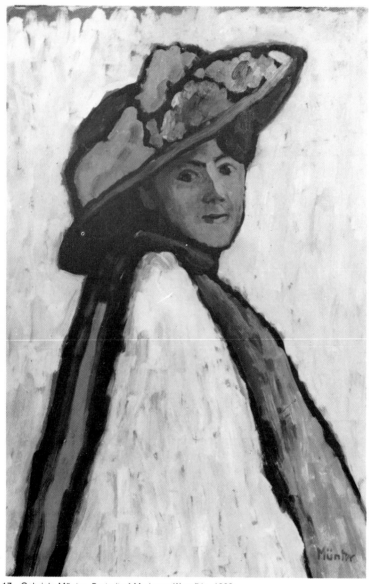

17 Gabriele Münter, *Portrait of Marianne Werefkin*. 1909

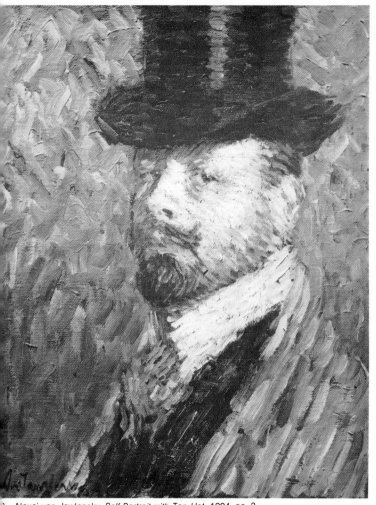

3 Alexej von Jawlensky, *Self-Portrait with Top Hat.* 1904, no. 3

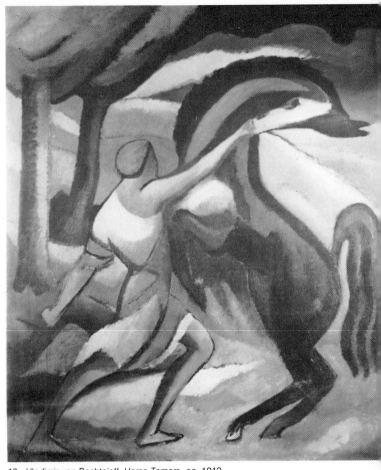

19 Vladimir von Bechtejeff, *Horse Tamers.* ca. 1912

20 Adolf Erbslöh, *Upper Bavarian Mountain Landscape near Brannenburg*

approval by the board of selection, so long as the canvases were not larger than four square meters. This rule was to play an important part.

They invited several guests, who however did not raise the quality of the group's work: Emmy Dresler, a member of "Phalanx" and an anthroposophist; the Frenchman Pierre Girieud; Robert Eckert; and Carla Pohle. Public response was negative. "Indignation and the laughter of the crowd, and insults from the press were the external outcome," writes Otto Fischer. The reaction doesn't seem all that unfounded: The exhibit was as heterogeneous as the views and abilities of the artists. It was only the second exhibition — in September 1910, at the same place — that revealed a sharper profile and a much higher quality. Among the German participants, the picture was pretty much the same. Paul Baum and Carl Hofer had left. But the Germans now began to group according to common interests: on the one side, Kandinsky and his

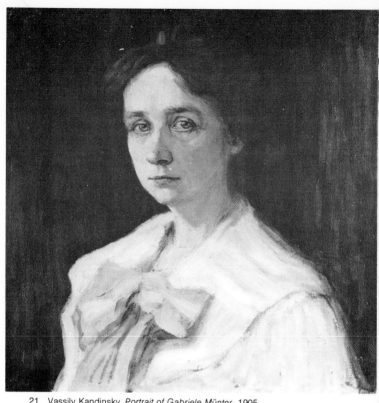

21 Vassily Kandinsky, *Portrait of Gabriele Münter.* 1905

circle of friends, with works based on *Jugendstil* tinged by eastern
European and French Fauve influences — more decorative than
expressive, but still revealing a definite goal. The other group was
formed by the painters of the Munich milieu of *Jugendstil,*
symbolism, and nature lyricism, despite the beginnings of timely
formulations, recognizable more and more as a delaying element in
European development. The center of gravity lay in the works of
foreign guests. Braque, Derain, van Dongen, Le Fauconnier,
Picasso, Rouault, and Vlaminck had sent in paintings announcing

22

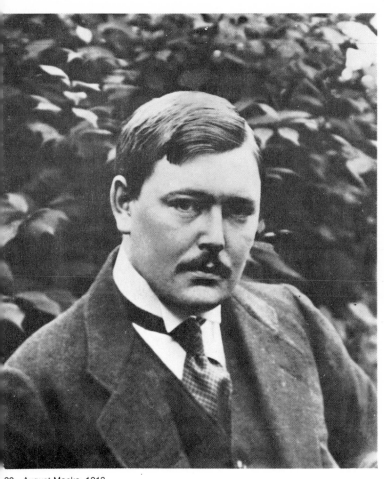

22 August Macke, 1913

the imminent struggle of cubism. Also important was Russian participation: works by the Burljuk brothers (co-founders of the Moscow futurist group, 1910) as well as Vassily Denissoff and Alexander Mogilewsky, along with the members Bechtejeff, Jawlensky, Kandinsky, and Marianne von Werefkin.

The critics were no kinder this time. The newspapers said angry things about the "western-eastern apostles of the new art." "There are two possible ways of explaining this absurd exhibit: we may assume either that most of the members and guests of the association are incurably mad, or that we are dealing with shameless bluffers who are not unfamiliar with the contemporary need for sensation" (*Münchener Neueste Nachrichten*). "They also write mysterious things about art," remarked the critic of *Kunst für Alle* (*Art for All*), "now they are fantasizing with brushes and crayons like fever patients. . . . Contents and motifs are strictly taboo" — a certainly not altogether imprecise observation if we focus on the works that demonstrate freer formal rhythms and color sounds, despite the still prevalent dependency on the model of nature.

The text of the catalog was programmatic. But it excels, especially with Le Fauconnier and Kandinsky, in a relatively cogent description of the new formal means and goals (see pp. 96 ff). August Macke, who visited the show twice, did feel the internal conflicts, for instance the fragmentary character of some of the attempts. His opinion was expressed in a letter to Franz Marc on December 26, 1910: "The *Association* is very earnest and, for art, I prefer it to all the others. But — it doesn't shake me. . . . Bossi, Münter, and Kanoldt are perhaps the weakest and hence the most obvious. Kandinsky, Jawlensky, Bechtejeff, and Erbslöh have an enormous artistic sensibility. But the means of expression are too great for what they want to say." What Macke tried to articulate here describes the situation exactly: Kandinsky's Fauvism intensifying itself toward an autonomous picture, the *Jugendstil* esthetics wandering off into the decorative or sentimental, the monumental poses of nature lyricism among the weaker artists.

However, this exhibit marked a tremendously consequential encounter. One enthusiastic voice was raised among the opposing voices. "Thannhauser showed us a letter from a Munich painter whom we knew; he congratulated us and expressed his enthusiasm

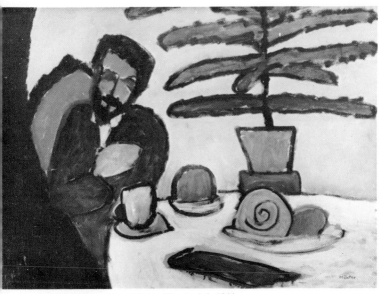

23 Gabriele Münter, *Man at Table* (Kandinsky). 1911
Reproduced in *The Blue Rider* almanac

in eloquent words. This painter was a 'genuine Bavarian,' Franz
Marc" (Kandinsky). Because of his pamphlet "On the Exhibition of
the *New Artists' Association* at Thannhauser (1910)," Marc was
unanimously asked to join the group and elected to the managing
board. Kandinsky thus received a support that could not be
overestimated. However, the friendship between the two like-
minded artists must have deepened the gap between the
above-mentioned factions. In January 1911, Kandinsky resigned as
chairman, citing "differences in principle between the basic
viewpoints." He was succeeded not by Jawlensky, the assistant
chairman, but by Erbslöh, who, together with Kanoldt, rep-
resented the opposing party. Marc, sensing imminent conflict,
tried to get Macke in as a member and thus as a supporter of his
own camp. "Why don't you see to it that you join us as soon as
possible, and for the following reasons: together with Kandinsky, I

25

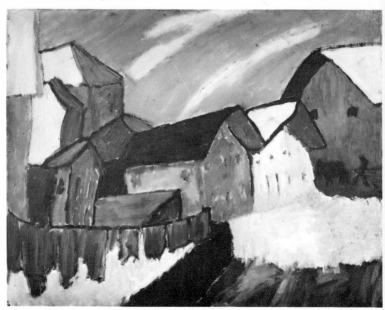

24 Gabriele Münter, *Village Street in Winter*. 1911

can clearly foresee that the next jury (in late autumn) will be involved in a dreadful conflict, and that now or next time there will be a dreadful split or a withdrawal of one or the other party; and the question will be: Which will stay?" (8/18/1911).

Macke would not join: "I had to reflect on my own thoughts outside of all those art politics, which distract one all too much." Nevertheless, Macke zealously propagated the artistic goals of the Kandinsky group in the Rhineland. Subsequent exhibits in Karlsruhe, Mannheim, Hagen (the Folkwang Museum); and Dresden created a new resonance, but also increased the number of adversaries. The well-known art dealer Cassirer, who wanted to sponsor the show in Berlin, withdrew at the last moment: "The reason: these are not, as the contract stipulates, 'the works of Munich artists!' " (Marc to Macke, 1/14/1911)

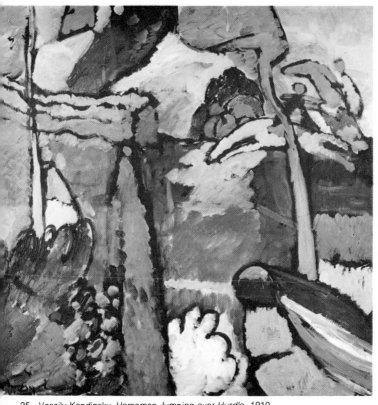

25 Vassily Kandinsky, *Horseman Jumping over Hurdle.* 1910

The vehement controversies between the traditionalists and the progressives, which took place not only in Munich, culminated in a pamphlet written by Carl Vinnen, a Worpswede painter, and published by the Eugen Diederichs publishing house in Jena. Vinnen, prompted by the purchase of a Van Gogh painting by the Bremen's Kunsthalle, strongly condemned the influence of foreign art. Above all he attacked gallery owners who were open to the new

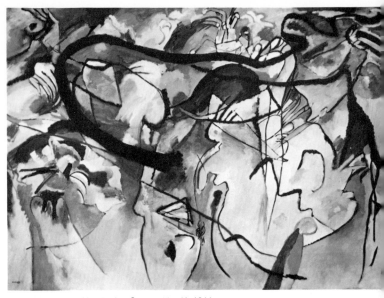

26 Vassily Kandinsky, *Composition V.* 1911
(rejected for the third exhibit of the New Artists' Association)

art, and he was unreservedly supported by "national-minded"
artists, museum directors, and writers. This attack provoked a
harsh retort in *German and French Art,* put out by the young
R. Piper publishing house in Munich. The participants were not
only the artists directly concerned like Marc and Kandinsky, but
also such prominent men as Gustav Pauli, K. E. Osthaus,
Wilhelm Hausenstein, Alfred Lichtwark, Wilhelm Worringer and
such important artists as Liebermann, Rohlfs, Slevogt, and Uhde.
In the midst of this ferment, a rupture occurred in the *New Artists'
League.* During preparations for the third show, Kandinsky's
Composition V (ill. 26), which exceeded the size limit for non-juried
works by only a few centimeters, was submitted to the jury and
then rejected by the Kanoldt/Erbslöh group. This affront caused
not only Kandinsky but also Marc and Gabriele Münter to leave
immediately. Kubin, Thomas von Hartmann, and Le Fauconnier

declared their solidarity. Jawlensky and Marianne von Werefkin tried to mediate in order to save the association, but it was useless. The following year, tired of the quarrels among the remaining members, they too resigned. Bereft of its leading personalities, the *New Artists' Association,* which had been founded with so much hope, soon disbanded. Of course, the third exhibit took place as scheduled, from December 18, 1911, to January 1912, but in a smaller number of rooms. In the adjacent space, the members of the Blue Rider launched their first show on December 18, 1911, thus starting out on their public route.

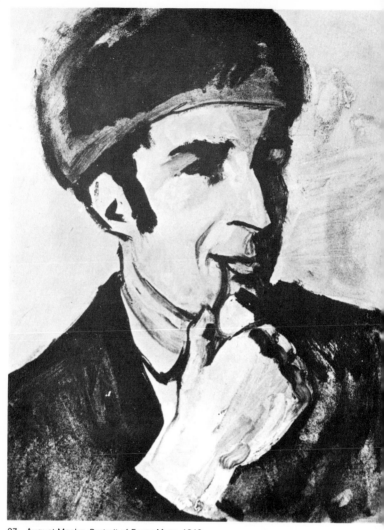

27 August Macke, *Portrait of Franz Marc.* 1910

The Blue Rider —
Book, Shows, Artists

One day after the jury meeting which marked the definitive break, Franz Marc wrote to his brother: "Now the two of us have to keep on fighting! The 'editorial board of *The Blue Rider*' will now be the starting point for new exhibits....We will try to become the center of the modern movement." These lines, as well as the speed with which the first show was put on as a counter-demonstration against the *New Artists' League*, reveal that the Blue Rider cannot be regarded as the consequence of the final conflict. As we learn from K. Lankheit's new documentary edition (1965) — which the present volume essentially follows — Kandinsky, in June 1911, had already thought of a yearbook that would make known the intellectual trends of the period as the artists saw them. There was no dearth of preparatory work. Kandinsky's manuscript *On the Spiritual in Art* was completed in 1910, but he could not find a publisher for it. (It did not come out until late 1911, published by R. Piper, with a second edition in 1912.) Undaunted by the first rejections, Kandinsky had instantly begun planning another publication. The time seemed ripe, the "direction towards a grand goal" demanded public discussion. An almanac, an illustrated yearbook surveying the current scene, struck him as more suitable to that end than a new book. However, artists, and not just painters, were to take part. It is obvious that he also regarded such a publication as an opportunity to develop certain ideas from his last manuscript. The article "On the Question of Form" in *The Blue Rider* is based on Kandinsky's texts of 1910.

A letter to Franz Marc, dated 6/19/1911, states Kandinsky's ideas very precisely. It may be seen as the birth certificate of the Blue Rider:

28 V. Kandinsky, Title woodcut for the catalog of the First Exhibit. 1911

Well! I have a new plan. Piper has to provide the publishing and we two have to be the editors. A kind of (yearly) almanac with reproductions and articles...and chronicle!! i.e. reports on shows — criticism only by artists. This book has to mirror the entire year, and a chain to the past and a ray into the future must give this mirror its full life....We'll have an Egyptian next to a little Zeh (the name of two children with a gift for drawing — Author's note), a Chinese next to Rousseau, a folk picture next to Picasso, and so on and so forth!...

Franz Marc seized upon the plan enthusiastically. Reinhard Piper, whom he had met in 1909, had made a name for himself among progressive painters when he put out the retort to Carl Vinnen's pamphlet. "It was practically a matter of course that Marc offered me this book," Piper recalls in his memoirs. He did all he could to help the work along, lending photo stereoblocks and contributing originals from his own collection of graphics. He did, however, energetically oppose the term "almanac" and he got his way, albeit at the last moment. Lankheit has shown that Kandinsky

KANDINSKY

**ÜBER
DAS GEISTIGE
IN DER KUNST**

29 V. Kandinsky, *On the Spiritual in Art*. Munich, 1911

removed the original term just before the title woodcut went to press.

The problem of funding was difficult. Given the recent establishment of his publishing house, Piper agreed to put the book out only against a financial guarantee by the two editors, who bore sole responsibility for the text: "Mssrs. Franz Marc and V. Kandinsky have joint liability for the costs." The required sum of three thousand marks was hard to procure, especially since Hugo von Tschudi, whose good offices they were counting on, fell seriously ill. He was replaced by someone else: Bernhard Koehler, August Macke's uncle, Franz Marc's patron, and a constant helper of young artists: "Without his helping hand, *The Blue Rider* would have remained a lovely Utopia" (Kandinsky).

A letter of 9/1/1911 testifies to the speed with which Kandinsky pursued his idea:

> On the other hand, I've written to Hartmann, telling him about our union and awarding him the title of an 'authorized collaborator for

30–33 Vassily Kandinsky, Sketches for the jacket of the almanac *The Blue Rider*.
 1911

Russia'....I'm also writing to Le Fauconnier....I've asked Hartmann
to do an article on Armenian music and some musical correspon-
dence from Russia....Schönberg will write about German music. Le
Fauconnier will find us a Frenchman. Music and painting will be
properly illuminated. We'll include some musical samples too.
Schönberg has some songs, for instance. We could possibly ask
Pechstein to be our Berlin correspondent: he's unreliable — and
thus we'd be testing his strength....We simply have to show that
something is happening everywhere.

The term "almanac" had been given up, but not the idea of a
periodical publication. The contract itself refers to this possibility.
To be sure, the two editors also feared the inevitable restraint of
deadlines. Even now, their mode of operation, dictated by an
understandable hurry, could barely be maintained. Thus the
announcement speaks only of a publication to appear irregularly."
In mid-May 1912 the volume was distributed. The edition had
gone up to twelve hundred copies because of the unexpected success
of the subscription. By 1913 the second edition was being
prepared; Piper had had the foresight to keep the plates. No

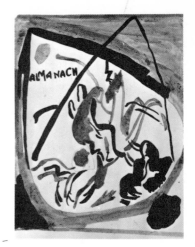

revisions were possible, but half a sheet was added. This provided space for the two forewords, which were rewritten (cf. p. 108). At the same time, the dedication to Hugo von Tschudi, who had died, was shifted to the right-hand page, and a few photographs were replaced. The new edition must have been distributed in the early summer of 1914. Meanwhile, preliminary work was being done on a second issue, about whose planned contents Lankheit has published some interesting facts. It did not come out, however.

The varied nature of the contents may be confusing at first glance (cf. p. 117). Yet it reveals not only the intellectual stance of the collaborators — aiming at a single goal although with individual interpretations, of course — but also their keen sense of their role as pioneers of a new era of intellectual culture in which the fine arts would be emphatically placed in the context of the other liberal arts. The original idea of a chronicle was also maintained, in the form of situation reports. As significant as the text are the illustrations. Not only do they show the works of collaborators and their friends — Paul Klee, for instance, is represented with a drawing — but they also document the wide

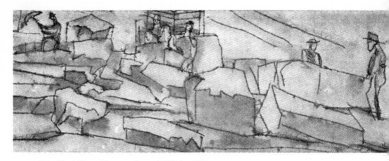

34 Paul Klee, *Stonecutters*. 1910 (no 74)
 Reproduced in *The Blue Rider* almanac

spectrum of themes with which the editors dealt. We discover a
medieval gravestone or silk embroidery as well as a Benin sculpture
or an Etruscan relief, Malayan woods and Mexican works or
Egyptian shadow-play figures, sixteenth-century German wood-
cuts, Japanese drawings, or Chinese paintings. El Greco is
represented, as are Van Gogh and Matisse, and there are even works
by Mueller, Heckel, and Nolde. But the pictorial section goes
beyond art and anthropology: There are children's drawings as well
as Bavarian votive pictures and glass paintings and Russian folk art.
The latter works precisely clarify what the Expressionists cited as
the basic foundation of the naive and primitive, the models of
expressive art unburdened by artistic tradition. And the sweep of
the spectrum daringly goes all the way to anti-naturalistic
movements in France, Germany, and Russia. Kandinsky, in his
essay "On the Question of Form," gave tips for a possible
understanding of the text by the unbiased reader. If the reader is
able to

> temporarily get rid of his wishes, his thoughts, his feelings and then
> leafs through the book, passing from a votive picture to Delaunay
> and then from a Cézanne to a Russian folk picture, from a mask to
> Picasso, from a glass painting to Kubin, etc., etc., then his soul
> will experience many vibrations and enter the territory of art....And
> these vibrations and the advantage that springs from them will
> enrich his soul, an enrichment that cannot be achieved by anything
> but art. Later, the reader, together with the artist, can go on to

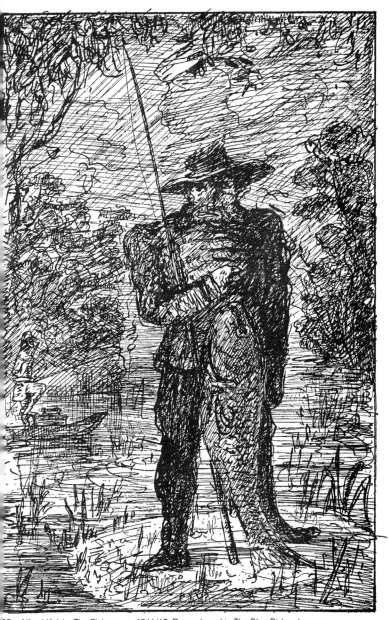

35 Alfred Kubin, The Fisherman. 1911/12. Reproduced in *The Blue Rider* almanac

36 Egyptian shadow-play figure.
Reproduced in *The Blue Rider* almanac

objective observations, scholarly analysis. He will then find that
here the examples harken to an inner calling — composition — that
they all rise from an inner basis construction.

Seeing the various contributions as part of the overall plan
touched on here is not difficult. One part is the general overview of
the European situation around 1911. When Franz Marc tells about
the German *Wilde* (Fauves) parenthetically in relation to the French
Fauves, he does not limit himself to the changes of the *New Artists'
Association*, some of which he experienced. The history of the latter,
like the liberating influence of the French and Russians, is at the
center. And it climaxes in the insight "that the renewal must not
be formal, it is a rebirth in thinking." He also reports on the
"well-known and much-described" Dresden *Brücke* and on the New
Secession in Berlin (co-founded by Pechstein to oppose German

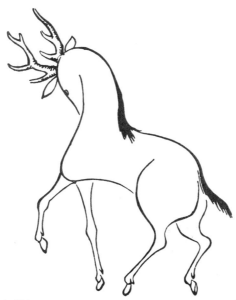

37 Japanese drawing.
Reproduced in *The Blue Rider* almanac

plein air painting). This movement is described as the original source of a torrent "that carries along all possible and impossible things, relying on its purifying power." He points out the "defiant freedom of this movement," yet one senses how much closer he feels to the West–East tendencies of the south German scene. Burljuk's essay on the Russian Fauves impresses upon us the bottleneck in which the young generation of Russian artists felt squeezed by the weight of traditional trends and groups. That must have been one of the reasons why the best talents sought contacts with the West. The essay culminates in the demand that we "throw back the dark curtain and open the window to genuine art." The extent to which this was possible is shown by the revolutionary history of the Russian development up to the early twenties; its full importance has been understood and evaluated only recently.

Roger Allard contributed an analysis of Cubism — both an interpretation and a justification — at a time when Cubism was on people's minds. Allard consistently stressed the primacy of form as the element of order and thus inevitably opposed the "mystical, inward construction" that Franz Marc envisaged as the goal of the new movement. Connected to this is the investigation of compositional devices in Delaunay, whose works were already strongly impressing the Munich artists and ultimately had a great influence on them.

August Macke's notes on the topic of "Masks" seem more like a poetic reading than an analytical study. He pursues the inner link between idea and form, which reveals itself in the works of so-called "primitives," in religious pictures, in the works of the naive, and in contemporary art: "Ungraspable ideas express themselves in graspable forms." There is an overlapping with Expressionistic views when Macke points out that scholars belittle "artistic forms of primitive nations by relegating them to the realm of anthropological artifacts or arts and crafts," whereas the artist recognizes "powerful utterances of powerful life" in them.

Kandinsky's contributions, in accordance with his importance in the circle of friends, take up the most space. They deal not only with the issue of form — on which he supplies analytical as well as subjective and timely studies — but also with the area of "Music–Painting," an interest he had repeatedly touched upon. Arnold Schönberg, a friend, occasional painter, a master of modern music, and founder of the twelve-tone technique, and the Russian composer, pianist, and painter Thomas von Hartmann were partners with whom Kandinsky could clarify problems and work out approaches to solutions. The friend and patron of the vanguard, Dr. N. Kulbin, a physician in St. Petersburg, also contributed to this section.

Schönberg's text, as can be expected, is germane to Kandinsky's reflections. Both artists must have inspired and influenced each other during those years. For Schönberg, as a musician, a text means little for the true understanding of music. Likewise, he views "with great joy" as parallels in the plastic arts those works of painting "for which the concrete external object is hardly more than an occasion to fantasize in colors and forms and express oneself in such a way as only musicians have hitherto expressed themselves."

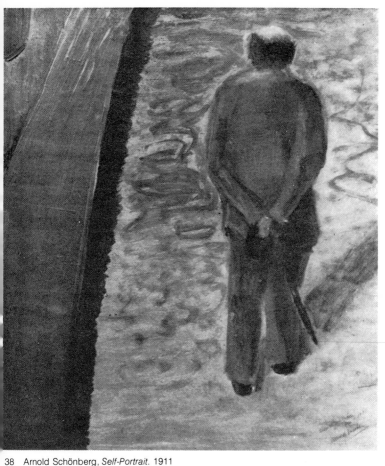

38 Arnold Schönberg, *Self-Portrait*. 1911
 Reproduced in *The Blue Rider* almanac

Similar analogies occur in Kulbin's article on free music. He concludes that by a certain union of notes, more narrow than determined by traditional rules (he demonstrates the method), one can achieve musical images "that consist of special color planes which fuse into running harmonies, similar to new painting" — "color music."

Kandinsky and Hartmann had already been brought together by common interests in 1909. Hartmann's essay "On Anarchy in Music" surely goes back to the conversations the two artists had been having since that time. Once again, "internal necessity" is emphasized as the point of departure, and the "essence of beauty in the work" is defined as "the correspondence between the means of expression and internal necessity." These were thoughts that Kandinsky himself might have articulated. The collaboration continued in the painter's stage composition *The Yellow Sound,* a work that Hartmann much later called "the most daring adventure of our time in stage art." He reworked the musical part of the play, which vanished in the chaos of the Russian Revolution and was taken up again only in 1956.

This aspect clarifies Sabanejew's contribution. The Russian composer and writer on music did a study of Skrjabin's *Prometheus,* and we can see a distinct relationship to Kandinsky's ideas. After all, the goal is to synchronize music with the change of colored illumination. "In *Prometheus,* the music is practically inseparable from the color harmony....Every key has a corresponding color; every change in harmony a corresponding change in color." Once again, we find the parallelism of painting and music, but now also in terms of the "reunification" of "all the scattered arts" under the "mystery of the fundamental idea."

Kandinsky's "On Stage Composition" (the postulation of his stage work) and *The Yellow Sound* conclude *The Blue Rider;* and that is logical. Here he attempts the synthesis that was a beckoning vision in German Romanticism. A century later, it could be theoretically grounded but not realized. Kandinsky tried hard to make it come true even years later.

The somewhat daring approaches and conclusions of the texts should not make us forget that the book appeared in 1911. It marks the start of a tempestuous development that was to last until 1914. The volume should therefore be viewed as a prelude rather than a

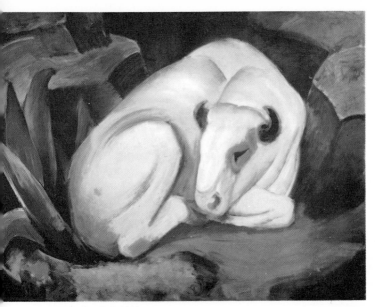

39 Franz Marc, *The Bull.* 1911
Reproduced in *The Blue Rider* almanac

summing-up. Hence the variety of opinions despite the common
goal of the "spiritual in art" and its realization. In 1911, the theory
was still way ahead of the practice. But by 1912/13 the possible
ways were much clearer. This also holds true for the poles of
German and French development, which were seen as incompati-
ble: form and content — both, however, "spiritual." The route of
the French — whether Fauves or Cubists — was still determined by
Cézanne's reminder: "Art is a harmony parallel to nature." — Art
as the ordering overstructure which puts color and form as
compositional devices in the service of a new pictorial reality, as an
utterance of internal order and constructive harmony.

Franz Marc represented the German counterposition. For him,
liberation from naturalism meant an awakening consciousness of a
vaster participation in being. Basically, it was the legacy of German
Romanticism, the realization of that "mystical, inward construc-

tion of the picture of the world," that E. L. Kirchner called "the great secret." It was the task of artists "to work towards creating symbols for their time that would belong on the altars of coming intellectual religions." From this point of view, the described attempt is particularly topical — dealing with the musical traits of pictorial vocabulary (and vice versa), relating notes and visual sounds, and thus developing a theory of harmony of colors and forms that permitted a compositional application as in music. This detachment of color from objective reality did not take away from its sensory character; it actually emphasized it by freeing it from the ballast of content and allegory. Thus the expressive had a different key here than in the north, which impeded an understanding between the artists.

When the volume appeared, the first exhibit of the editorial board of *The Blue Rider* had taken place almost six months earlier. We know the reasons for the haste, which also prompted the publisher Piper to get the book *On the Spiritual in Art* out fast enough so that at least this programmatic piece was available along with the brief catalog of the show.

The names of the artists invited were, as expected, identical to those familiar to us from the circle around Kandinsky. There were a few new ones, so that the catalog lists: Albert Bloch, an American living in Europe until 1921; the brothers David and Vladimir Burljuk; Heinrich Campendonk of Krefeld, whom Marc had persuaded to settle near him in Sindelsdorf in 1911; Robert Delaunay, E. Epstein, Kandinsky, August Macke, Franz Marc, Gabriele Münter; the Swiss Jean Bloé Niestlé, who had known Marc since 1906 and had also been living in Sindelsdorf since 1910; and finally the composer Arnold Schönberg, who was also a painter. Nor was the "father of the naives," Henri Rousseau, lacking. Furthermore, in memory of Eugen Kahler of Prague, just recently deceased, they showed a few of his works.

All the artists represented the idea that Kandinsky formulated in his terse introduction: not a stress on similarity, but an emphasis on the individuality of like-minded artists pursuing a common aim between the two poles of a future art, "great abstraction" and "great realism," here indicated by the two antipodes Robert Delaunay and Henri Rousseau.

The final breakthrough to abstract painting could not be expected in this first demonstration of their energy and opinions.

Such a plan was even beyond the aspirations of Kandinsky, who, as is known, still saw abstract form as one of the many possible border points of art. This is confirmed by the selection of his own works. He showed *Composition V* (ill. 26), which the jury had rejected, *Improvisation No. 22,* and *Impression of Moscow* (ill. 40). The three paintings are exemplary representations of those three "original sources" that the painter cited as the foundations of contemporary painting in *On the Spiritual in Art*:

1. The direct influence of "external nature," expressed in a graphic and pictorial form. I call these works "impressions";
2. mainly unconscious and mostly sudden expressions of internal occurrences, that is, impressions of "internal nature"; I call this kind "improvisations";
3. expressions forming similarly in me (but very slowly), tested and worked out at length and almost pedantically by me after the first drafts. I call these pictures "compositions."

Besides a drawing, Robert Delaunay also exhibited four paintings, which must have been a distinct focal point: *St. Séverin* (1909, ill. 41), *The City* (1910), *The Tower* (1911 — one of the most important versions of his chief theme, "the Eiffel Tower"), and *The Town* (1911, ill. 42). The artistic problems of these paintings were extremely topical. With the *St. Séverin* series begun in 1909, the artist had first dared to try to translate Gothic spatial architecture into abstract pictorial rhythms, still quite analytically and hence close to the model. The growing distortion was based on the desire to make movement and intrinsic laws more visible, and thus remove the picture from the real motif. The "Eiffel Tower" series, begun in 1910, was a decisive step forward. Out of the shattering of external form, Delaunay filtered the expressive vision, the "dynamism" that the Italian Futurists had just proclaimed as the "absolute of modernity." Now color, previously mellowed, became brighter. Like form, color too began shaping motion and rhythm out of itself alone. All this verged on the abstract, yet revealed a distinct structure of order. We can understand how deeply such works affected the receptive minds of the southern German painters, especially the autonomy of the medium of "color" — the pictorial element that Guillaume Apollinaire later called "Orphic."

While Kandinsky's works, along with Delaunay's, marked the decisive starting point for the coming development, Marc's four

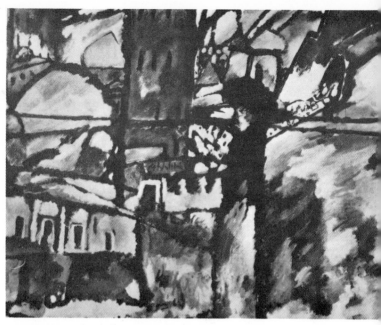

40 Vassily Kandinsky, *Impression 2* (Moscow). 1911, 114

paintings showed transitional solutions: *Yellow Cow* (plate 6), *The Blue Horses, Landscape,* and *Deer.* The residue of naturalism had not yet been sloughed off. Color was introduced only slowly to intensify the content and as a pictorial rhythm. It demanded a rechecking of objective forms whose material gravity had once opposed the spiritual sound.

Macke submitted three works, including a painting entitled *The Storm* (plate 7), in which his sense of belonging to the Blue Rider group was articulated a bit too pointedly. In its abstract, symbolistic conception and in its recognizable formal dependence on Kandinsky and Marc, the painting seemed alien to Macke's otherwise independent *oeuvre*. In spite of his friendship with Marc, Macke had kept critically aloof from the goals of the Blue Rider. He had repeatedly warned Marc that as a Blue Rider he was

thinking too much about the spiritual. This was based on the insight that striving for cosmic dynamics, for mystical sounds, tended to neglect the real problem of his art, visual poetry and the laws of color and form. He felt closer to Delaunay's direction; a painting like *The Storm* remained an exception.

Measured by the impact of their works on the current artistic situation, the other painters recede a bit behind the ones already named. Schönberg's visionary portraits, Vladimir Burljuk's Cubist rhythms, which also aim more at sound than form, Münter's naively colored compositions, Niestlé's delight in nature, seem peripheral. They were carried along by the great torrent of the period, but they did not determine its course.

The effect of the exhibit was not limited to Munich. It was next shown in the Cologne *Gereonsclub,* impressing the so-called Rhineland Expressionists, who were already in contact with the Munich scene by way of Macke and Campendonk. Herwarth Walden surprisingly ordered the show for Berlin, where he had it launch his Sturm Galleries. He added works by Jawlensky, Klee, and Kubin. It then moved to Bremen's United Workshops for Art in Craft. That summer it was shown in the Folkwang Museum; and that fall, in Frankfurt's Goldschmidt Salon. The Berlin show in particular was taken very seriously by the Blue Rider circle. They tried to raise the quality and to borrow some more works. "Berlin is important enough for that" (F. Marc, 3/1/1912).

While the first show was moving through Germany, the artists were already preparing for their second show. It took place from February 12 to April 1912 — not at Thannhauser, however, but at the Hans Goltz art shop. The catalog calls the show "black/white." Some artists, though, were represented not by drawings or prints, but watercolors. Marc and Kandinsky had initially planned a vaster show. But, probably recalling the times of the *New Artists' Association,* they were rather dictatorial in selecting the participants and the works. "Marc and I took everything that we freely chose without worrying about any opinions or wishes."

The participation was international once again. The French contribution was important, as always: Georges Braque, Robert Delaunay, Roger de la Fresnaye, André Derain, Pablo Picasso, Robert Lotiron, and Maurice Vlaminck. The Germans, aside from those living in and around Munich, were: Albert Bloch, Maria

47

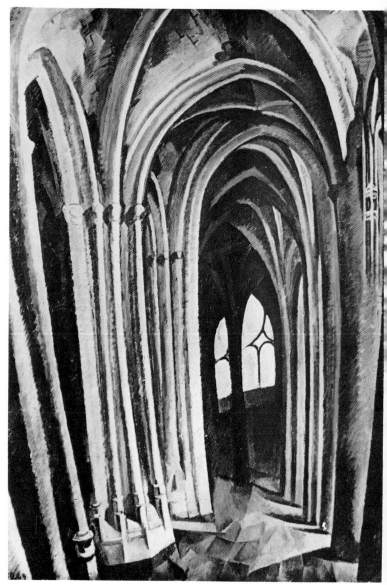

41 Robert Delaunay, *St. Séverin.* 1909
Reproduced in *The Blue Rider* almanac

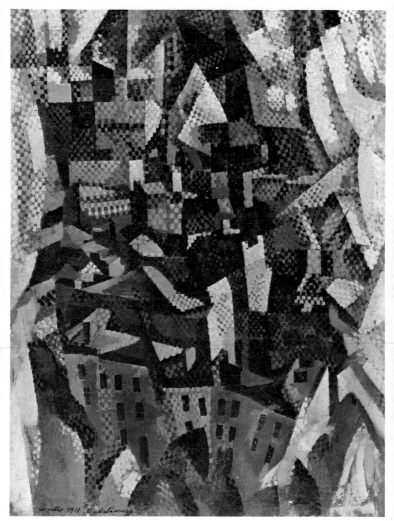

42 Robert Delaunay, *The Town*. 1911

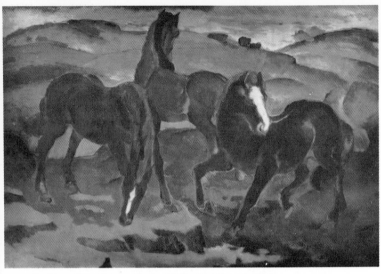

43　Franz Marc, *Grazing Horses IV (The Red Horses)*. 1911

Franck-Marc, Vassily Kandinsky, Paul Klee, Franz Marc, Gabriele Münter, Alfred Kubin, and the *Brücke* artists Heckel, Kirchner, Mueller, and Pechstein, but not Schmidt-Rottluff. There were also: Emil Nolde, Georg Tappert, the Westphalian Morgner, and Moriz Melzer, who lived in Berlin. From Switzerland came: Hans Arp, Walter Helbig, Wilhelm Gimmi, and Oscar Lüthy. Russia excelled with its avant-garde: Natalia Gontscharowa, Michail Larionoff, and Kasimir Malevich.

It is not easy to evaluate the show retrospectively on the basis of the meager catalog data and the tiny reproductions. Kandinsky's twelve water colors must have lent a highly emphatic accent. They came from the period in which his linear work visibly changed towards free, expressive arabesques, with traditional perspective abandoned in order to place the picture in a cosmic context, as a complicated colorful sound-work in irrational spaces.

The fact that Klee was represented by seventeen drawings seems almost self-evident at that point in time. He and Kandinsky had met in 1912, when Louis Moilliet, who was staying with Klee, bought some of the Russian's paintings from his studio. "Pictures

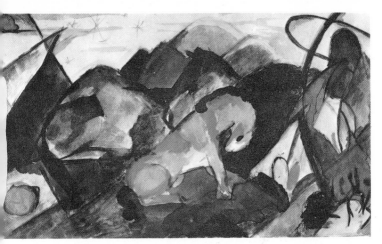

44 Franz Marc, *Resting Horses*. 1913

without an object...very odd paintings" (Klee). The plot thickened. Kandinsky became interested in Klee's bizarre, inscrutable hieroglyphics. The polyphony and rhythms of these hieroglyphics already hinted at their future role as an operative force between the unconscious and the picture as a "simile for the totality of the whole" — still hesitant, groping for limits, inching along the primal area of the pictorial. The two artists met, and, "going home in the trolley, we made plans to see more of each other. In the course of the winter, I joined his Blue Rider" (Klee: *Diaries*, 1912.903). Klee's slightly restrained commitment was based on a related stance, from which he also shared the ideas of the almanac: "There are, you see, still primal beginnings of art, such as one actually finds in anthropological collections or at home in one's nursery....If all the trends of yesterday's tradition really peter out...then the great moment has come, and I greet those who collaborate on the coming reformation" (Klee: *Diaries*, 1912.905).

It may surprise us to find, along with these Munich artists, the Westphalian Wilhelm Morgner (a pupil of Georg Tappert, also exhibiting), who exhibited sixteen works. However, Morgner was

45 Franz Marc, *Sleeping Shepherdesses*. 1912

looking for a dramatic stylization of form, always leading back to rhythmically ornamental, beautiful lines (one such work is reproduced here). And this quest conceivably had certain parallels to the ideas of the Blue Rider.

The participation of the *Brücke* painters and Emil Nolde goes back to the contacts between Franz Marc and the Berlin Expressionists during 1911/12. He had praised their "enormous, billowing wealth...which belongs with our ideas no less than the ideas of the quiet men in the country." He saw their "extremely powerful works" as vitally complementing the southern German situation. Nolde, above all, must have exerted an extraordinary fascination on him. Kandinsky, on the other hand, had reservations; he could not identify with certain intrinsic features of these Expressionistic works: the vehemence of their technique, the direct tackling of the problems, the lesser subtlety (compared with the French) of colors and forms. Kandinsky stuck to the judgment he had passed while preparing the anthology: "Such things have to

46 Vassily Kandinsky, *Composition* II. 1911

be *exhibited*. But to immortalize them in the document of our present-day art (and that's what our book is to be) as a somehow decisive, directing force — is not right in my eyes. I would at least be against *large* reproductions....The small reproduction means: this *too* is being done; the large one: *this* is being done."

Thus the Expressionists did take part in the black-and-white show with a large selection of their graphic works. But Pechstein's originally planned contribution to the anthology did not appear. Yet this artist was represented with more works than Heckel, Kirchner, Mueller, or Nolde, which emphasizes the fact that he was seen as the "typical" Expressionist. His more conciliatory style, his bent for beautiful lines and colorfulness, did not frighten the public as much as the uncompromising hardness of the other painters.

All in all, the exhibit offered a survey of certain focal points in the contemporary scene. It thus operated as an expanded pictorial section for the texts of *The Blue Rider* book. Such a vast overview

was never repeated. In May 1912, the artists participated in the *Sonderbund* show in Cologne. The group exhibition planned by Marc and Kandinsky had not been accepted by the directors of the show. Also, several paintings were rejected by the jury, which annoyed Kandinsky, who was particularly sensitive about such matters. Despite Macke's tireless efforts on behalf of his friends, and despite a quite important contribution of the Blue Rider to this international scenario, the hoped-for effect did not fulfill the wishes of the Munich artists, who had possibly wanted too much. Thus, despite Macke's qualms, they gave their rejected paintings to Herwarth Walden, who exhibited them that June in the *Sturm.* There, one year later, the "First German Autumn Salon" took place, a parallel to the renowned French "Salon d'Automne." In his new rooms on Potsdamer Strasse, Walden assembled 366 works of new European art, with eighty-five artists from twelve countries involved. Marc had quite plainly acted as an adviser, so that the selection clearly represented the viewpoint of southern German painters: Orphism, Cubism, Blue Rider. The *Brücke* painters were also invited, except for Pechstein, whom Marc called "respectably superficial à la Matisse." These painters, however, begged off, citing their commitment to the *Sonderbund.* Hence the German position was represented by the Munich artists and those allied with them: Kandinsky, Marc, Macke, Münter, Jawlensky, Kubin, Klee, Werefkin, and Feininger, whom Kubin had brought in. Nauen and Campendonk came from the Rhineland. Among the French, the Fauves and a few Cubists, including Braque and Picasso, were lacking. On the other hand, Le Fauconnier, Gleizes, Metzinger, and Laurencin were invited, as were the Italian Futurists. The fact that Delaunay had an important place need not be especially mentioned. Both the selection and the rejection marked the new focal points within the modern international scene, in which the Blue Rider circle was now fully integrated. No one had an inkling that the Autumn Salon was to be their last joint undertaking.

If we now look back to the beginnings in 1911, we can clearly see how quickly, in this short span of time, European art developed from a relative breadth of divergent approaches to a few concentrated focal points. These included expressiveness and the Cubist striving for order as two crucial positions of European art. If

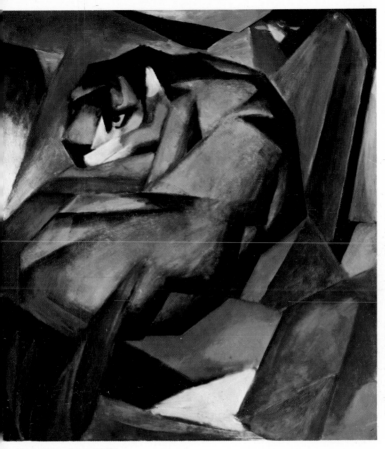

1 Franz Marc, *Tiger*. 1912

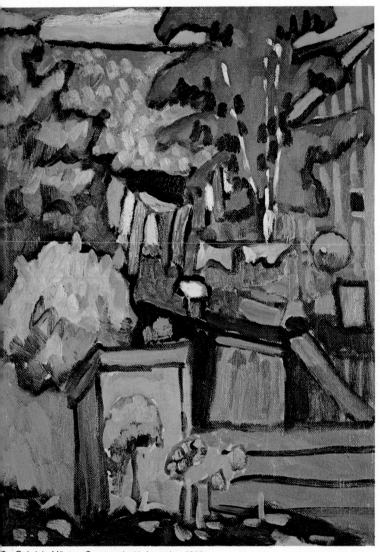

3 Gabriele Münter, *Courtyard with Laundry*. 1909

◁ 2 Vassily Kandinsky, *Arab Graveyard*. 1909, 85

4 Vassily Kandinsky, *Improvisation 3.* 1909

5 Vassily Kandinsky, *Landscape — Dunaburg by Murnau.* 1910

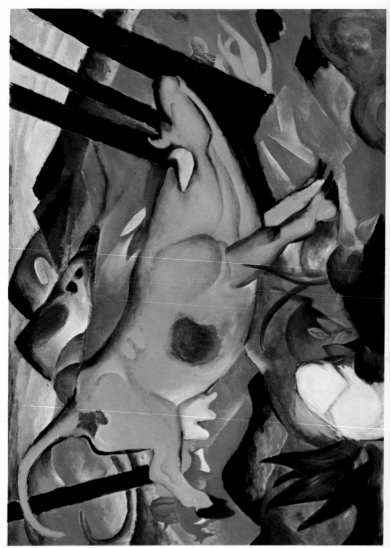

6 Franz Marc, *Yellow Cow*. 1911

7 August Macke, *The Storm*. 1911

Vassily Kandinsky, *Lyrical*. 1911

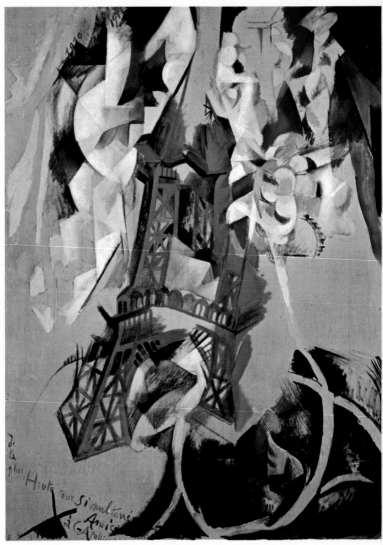

10 Robert Delaunay, *Eiffel Tower*. 1910/11

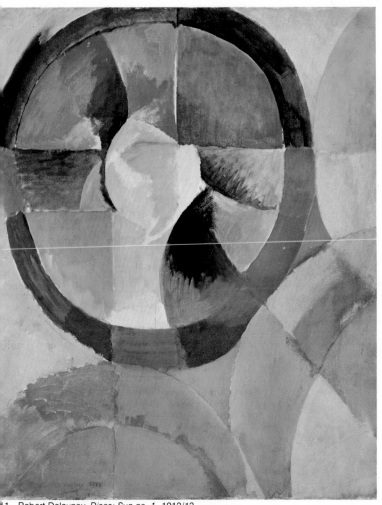

1 Robert Delaunay, *Discs: Sun no. 1.* 1912/13

3 Franz Marc, *Dead Doe*. 1913

12 Franz Marc, *Cats, Red and White*. 1912

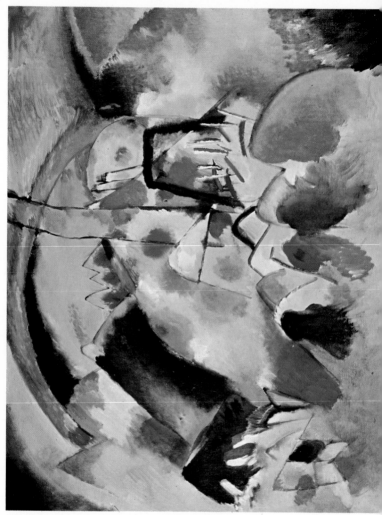

14 Vassily Kandinsky, *Landscape with Church I.* 1913

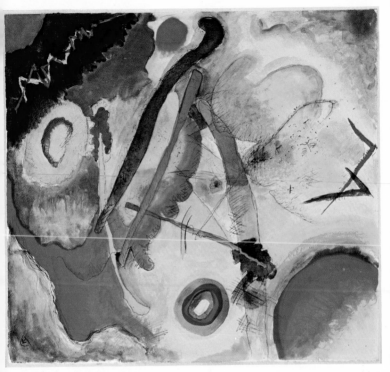

5 Vassily Kandinsky, *Water Color*. 1913

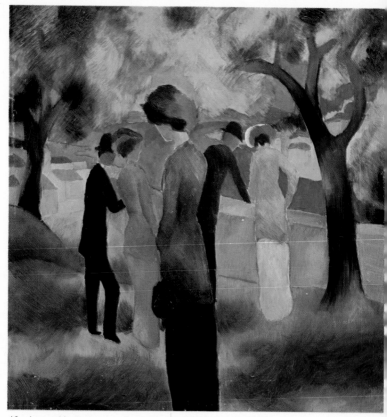

16 August Macke, *Lady in Green Jacket.* 1913

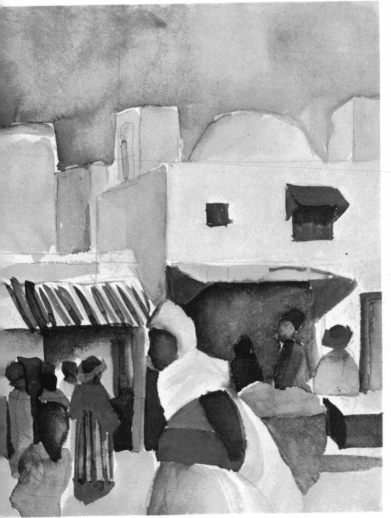

17 August Macke, *Market in Tunis I*. 1914

Franz Marc, *Battling Forms*. 1914

18 Franz Marc, *The Poor Land of Tyrol*. 1913

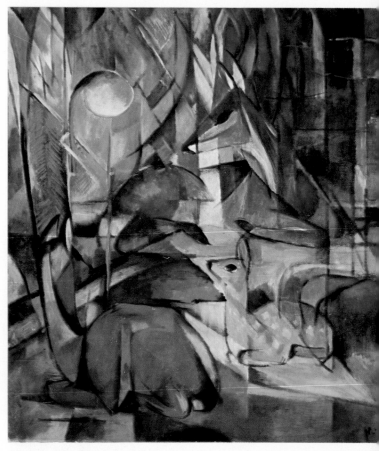

20 Franz Marc, *Does in the Forest II.* 1914

we do not understand expressiveness and constructiveness in too narrow a sense, then both directions, though seemingly opposite at first glance, were heading towards a common goal — to explore and expose the inner world — which gradually took shape between 1905 and 1914. Subliminal lines of energy between these two poles crossed in the paintings of the Germans and Russians affiliated with the Blue Rider. Most of the artists shared something with the Fauves (and thereby, initially, with the northern and central German Expressionists): the striving to form an imaginative counter-reality by passionately tackling and breaking up objective reality. During this process, pictorial devices could be cultivated to the point of pure color and pure line without forfeiting their newly won strength and freedom. The destructive process on the concrete level was matched by the ordering process on the formal level: expression was aimed at with abstract pictorial means. But here the Fauves and the Munich artists parted company with the Expressionists. The latter too, at this stage of maturity, rejected the elementary traits of color and form, taming representation into a symbol in order to intensify its emotional value. They thus similarly reached a concordance of image and expressive desire without, however, employing abstract form as the purest sensory sign. As close as the ties of the Blue Rider to Fauvism were certain affinities to French Cubism, which had filtered constructive pictorial form through analysis and synthesis of objective signs, thus achieving an overriding regularity. The inner and the outer picture overlapped in a pictorial formula. It was not, however, the repercussions of this severe principle of order, but rather Orphism, closely connected to it, that influenced the major Munich artists. In Cubism, color was limited to almost monochrome, scantily modulated, mellowed tones, to avoid restricting the priority of form. Orphism, however, was based on the radiance and effectiveness of pure colors, which proved to be on an equal footing in the pictorial construction. Only Robert Delaunay had gone a long way with this principle; hence, the deep impact of his art on the color-based works of the southern Germans.

The lesser talents followed the stimuli superficially, since they neither understood nor recognized their underlying principle. They decorated Cubistic formal elements with color or tried their hand at free plays of color. Two painters, however, represented the new

47　Vassily Kandinsky, *Improvisation 9*. 1910

attitudes individually and outstandingly: Vassily Kandinsky, whose pictorial intelligence always managed to tame the Fauvistic passion for color and Expressionistic emotionalism and subordinate them to his own goals; and Franz Marc, whose pantheism would not forgo content and who therefore developed color-form sounds, with which the experiences of this world would be integrated in a vaster existential context — what he called "mystical, inner construction."

48 Vassily Kandinsky, Water Color for "Study of Painting with White Edge." 1913

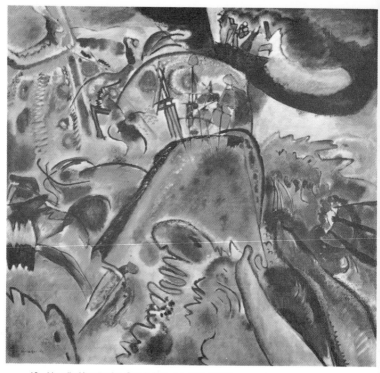

49 Vassily Kandinsky, *Small Joys*, no. 174. 1913

The years 1910–1912 were decisive for the growth and
development of the Blue Rider. During this period, Kandinsky's
works — his *Impressions, Improvisations,* and *Compositions* — were
still under the impact of objective experience. Even his theoretical
research focused on a greater liberation from those *Vibrations,* which
still derived from visual experience in order to ultimately express
contents in free sound. The *Compositions* aimed most directly at this
goal. If we compare their development until 1912, we can follow
the gradual waning of objects and the transition to free arabesques.
Only color had gained a larger independence earlier. Inserted into
musical harmonies or dissonances (we recall Kandinsky's many

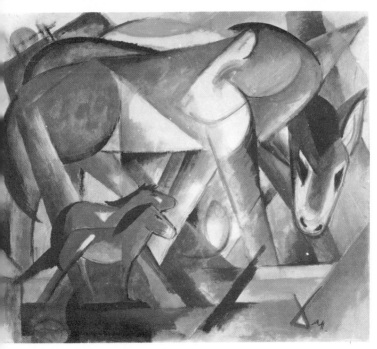

50 Franz Marc, *The First Animals*. 1913

efforts), color overwhelmed the pictorial construction and finally dissolved the remnants of illusionary perspective which had persisted in his paintings until then. The years between 1912 and 1914 were finally the time of Kandinsky's decisive struggle with Cubism, Orphism, and Futurism. This struggle ended with the achievement of the autonomous pictorial organism — free from any tie to reality — and a pictorial space that went far beyond the Cubist notion. Static construction of the picture was thus abandoned. Color, as a trace of movement, a bearer of emotion, or an arabesque of expression, dynamized the surface and brought in time and space as kinetic elements. This clear shift of the accent to

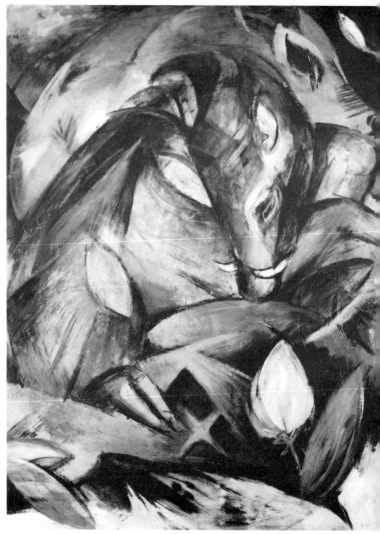

51 Franz Marc, *Wild Boar and Sow*. 1913

color had initially been aided by Delaunay. But soon Kandinsky's ideas aimed far beyond the rational conceptions of the French artist. The negation of the surface by the spatial distance value of color opened irrational pictorial spaces; their evocative power broke open spherical depths. The picture expanded into a cosmos, pulsating with the torrent of Dionysian sounds, which were no longer used melodically, but symphonically, by which the artist meant the harmony of several sub-motifs subordinated under a main motif. They could evoke associations and also hint at transcendencies, and they enveloped the most powerful contrasts: the rational and the irrational, the dynamic and the static.

Kandinsky's works of this period emanate an undeniably expressive emotionalism. Even their formal restraint is unable to conceal the basic reason: the yearning for eastern mystical expression. That was precisely what separated Kandinsky from the rational pictorial architecture of French Cubism. Great is his distance from this movement, which, according to Roger Allard in *The Blue Rider,* is "primarily the conscious will to have painting restore the knowledge of proportion, volume, and weight." Here the Russian's art once again touched the religious sense of cosmos in the German Marc: "Mysticism is awakening in the soul, and with it are also awakening the ancient elements of art." Kandinsky may not have directly shared this feeling, but he viewed it as a germane source of creativity.

Franz Marc's contact with Vassily Kandinsky coincided with a critical point in an artistic crisis: the painter was groping through reality without managing to forge all the way to its true gist and sense. His dealings with form had still not aroused the expected response in the spiritual. Macke brought the message of color that could be used spiritually and whose magical character, if grasped, opened that sphere of rapture in which the visible became a metaphor: "One no longer adheres to the picture of nature, one annihilates it, in order to show the powerful laws that rule beneath a beautiful appearance." In this situation, Kandinsky's cosmic visions must have struck the painter like a tremendous evocation — a dangerous lure from which his more distant friend Macke always wanted to hold him back. In point of fact, Franz Marc, constantly aware of Kandinsky's urgent presence, did choose a different path. Here too, the struggle with colorful Orphism, culminating in his

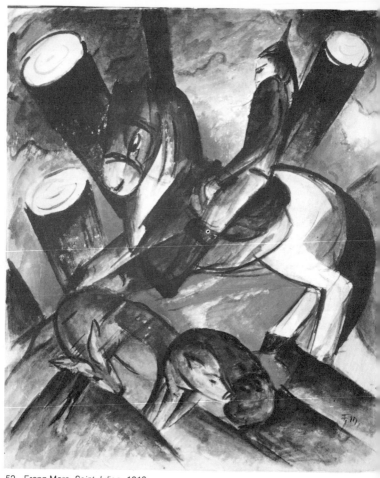

52 Franz Marc, *Saint Julian*. 1913

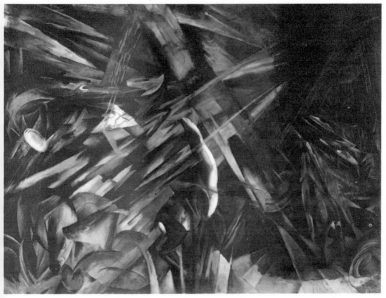

53 Franz Marc, *Animal Destinies (The Trees Show Their Rings, the Animals Their Veins)*. 1913

acquaintanceship with Delaunay in Paris in 1912, was the starting point for the crucial phase of his work. He saw a path marked out, a way of breaking up envelope of matter, replacing form with color vibration, but without giving up its expressiveness. The insights gained from the works of the Italian Futurists confirm the proximity of a new reality, mysteriously linked to the sources of being. Thus the arabesque acquired a metaphorical meaning. For in Franz Marc, the world and nature were not excluded, they were hermetically encoded in the new-found pictorial signs. They persisted in the expanded dimensions of painting.

Towards 1913, the concordance of color, form, and content was finally attained. It became the basis, "the yearning for indivisible being, the liberation from the sensory illusions of our ephemeral life," the tenor of Marc's creativity. In works of visionary urgency,

the painter depicted the integration of all life in the cosmic context, the legend of the metaphorical manifestation of all being. These works are filled with a yearning hope for universal harmony. It was not man, but the symbolic figure of the animal that opened the way to the felt world. Until around 1914, the indications of deeper meaning were tied to abstracted forms recalling objectivity. But they no longer designated anything real, they aimed at metaphysics: cathedral-like superstructures, light faceted like crystal, twitching lines, transcendent color structures responded like echoes to the uncanny being of the creature. The creature became the symbol of devoted poignancy, of the pantheistic sense of the world. Spiritually cleansed sounds revealed the identity of the Creator and his creations. Paintings like *Animal Destinies* (1913, ill. 53; originally called *And All Being is Flaming Suffering*) or *The Poor Land of Tyrol* (plate 18), touched unmistakably by medieval color mysticism, are located in those zones. Near, and yet remote, they are carried by the sound of color melodies that had never been heard before. At the end of 1913, Marc realized that there must be higher visions beyond the "animalization of the world," as he had once described his goal. He now no longer required any external prompting to take the last step to abstraction, borne by the thought of the scientific image of the universe. The artist admitted this influence to the extent that these notions "reorient our mind's eye." Marc's abstract creations are, by the way, not identical with Kandinsky's, since they contain amorphous organic primary forms: Nature remains encoded in them. The painter was not destined to try out the new paths. War broke out during this decisive stage, and in 1916 Franz Marc was killed in action at Verdun.

There is no contesting the fact that the idea and diffusion of the Blue Rider are based on the intensity and activity of two artists — Marc and Kandinsky. Certainly, the relative breadth of the movement and its effect beyond the local situation of Munich would have been unthinkable without the involvement of many painters. But these painters neither steered nor determined the development. Jawlensky remained totally outside; he didn't even take part in the exhibits. Gabriele Münter and Marianne von Werefkin reflect the commitment of their group of friends in their works, rather than contributing anything crucial. It was unarguably to Kandinsky's credit that he recognized the artistic potential

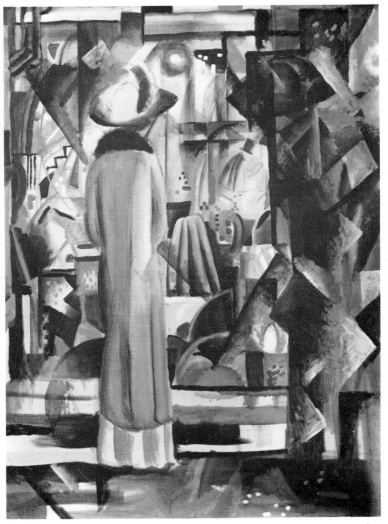

54 August Macke, *Large, Bright Shop Window*. 1912

of the young Paul Klee and asked him to join. But Klee was only just starting out at that time.

August Macke occupied a special place. At first he was fascinated by the revolutionary élan of the Munich circle and was in danger of conforming artistically. But Macke soon recognized the threatening confinement of his own ideas. He was certainly friends with Franz Marc for many years, and he always personally advocated the cause of his friends. But to go the customary way of including him in the narrower circle of the Blue Rider means overlooking the Rhinelander's growing detachment from the ideas of the southern German painters. He would not integrate and was just as strict about refusing to join the *New Artists' Association* as he was later on, during the flowering of the Blue Rider, when he insisted on an uncompromising demarcation between his and their artistic notions: "My views on art are different from Kandinsky's and Marc's. I now feel responsible for myself alone" (10/16/1913, to B. Koehler).

It may have been the programmatic manner of the Munich editorial group that caused Macke, who reacted more strongly to sensory impressions than to theoretical reflections, to remain aloof. Macke often expressed himself in trenchant terms, but Marc, nine years his senior, had a conciliatory, compromising way, and thus staved off the danger of harsher conflicts, though without removing their cause.

Certainly, the artistic starting points are not all that different from one another. In theory, Macke's art can easily be derived from a synthesis of Fauvism and Orphic Cubism, with undeniable influences of the Blue Rider. Far more decisive, however, than such a labeling is the poetic heightening of the visible to a personal expression. And that is what lends August Macke's art its unmistakable quality. The picture as the sensory sign of a deep, joyous response to the beauty of the world, as a metaphor of colorful order and pictorial harmony — here the crystalline structure of pictorial orders in a Delaunay must have been more deeply moving than the east European emotionalism of Kandinsky or the mysticism of Franz Marc. Indeed, Macke's encounter with Delaunay in Paris in 1912 did spark a development. From that point on, Macke's more repressed resistance to the Blue Rider became stronger and stronger. He now saw a way to let his spiritual

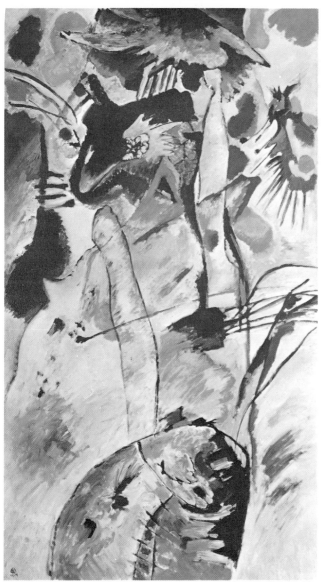

55 Vassily Kandinsky, *Mural for Campbell.* 1914 (summer)

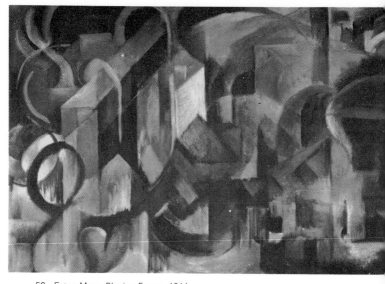

56 Franz Marc, *Playing Forms*. 1914

dealings with color, as influenced by Munich, lead to pictorial laws
that can heighten the image of the world, transforming and
reflecting it: painting as visual poetry, realized out of the medium
of pure color. Macke did not require the strict discipline of Cubism
which determined Delaunay's *oeuvre*. His art remained slightly
more sensual. The crystalline refraction of his colors did not follow
the laws of French art but were guided by the optical impression.
Macke let French stimuli flow into his own sensory perception. He
used them like a fine scaffold that helped to order the wealth of
visual impressions into a colorful pictorial pattern. He saw the
world in the metaphor of colors. He grasped beauty as the
equivalent of pictorial order: happy viewing brought forth a
purified picture of nature. In this intensified moment of being, the
painter had a special experience: a trip to Tunis in 1914 with Klee
and Moilliet. The thirty-seven water colors he did here are both
culminating and terminal points at the same time. As simple as
they are sublime, in self-evident beauty and perfection, these

pictures mark a stage in which the spiritual and the sensory totally intertwine. Only a few months later the painter died on the western front.

World War I brought an end to the history of the Blue Rider. The almanac records the spiritual and intellectual situation of the trend around 1911. The continuation, planned by Kandinsky and Marc for 1914 (of which we have at least some fragmentary knowledge), would have drawn a balance sheet of the efforts up to that time.

Attitudes towards art had changed more radically between 1910 and 1914 than the initiators of this upheaval could have sensed. For a short while, Munich with the Blue Rider was the focus of European artistic development. This was the scene of the crucial step to expressive abstraction, with which a young generation gave up the traditional trust in visible existence: they replaced imitation with simile, developing pictorial formulas for the invisible, and exposing the spiritual rather than formal construction of being. The

artists thus felt in harmony with the natural sciences. The second volume of *The Blue Rider* was to have been devoted to this harmony.

It was not a community but rather distinct individuals who set the direction and put their stamp upon it. Thus the esthetics of the Blue Rider are inevitably different from those of northern German or *Brücke* Expressionism. But these trends have something in common that links them: that overriding sense of existence, which we perceive to be the true characteristic of that period.

Documentary Appendix

Vassily Kandinsky: The Blue Rider (A Retrospective View)

Dear Herr Westheim,

You have asked me to arouse my memories of the genesis of the Blue Rider. Today — after so many years — this wish is justified, and I am very glad to fulfill it.

Today — after so many years — the atmosphere in the beautiful and, despite everything, still charming city of Munich has changed thoroughly. Schwabing, once so loud and restless, has become still — not a single sound can be heard there. It's too bad about lovely Munich and even more so about the somewhat comical, rather eccentric and self-confident area of Schwabing, in whose streets a person — whether male or female ("womenfolk" as the Bavarians call them) — instantly stood out if he didn't have a palette, or a canvas, or at least a portfolio. Like a "foreigner" in an out-of-the-way nest. Everyone painted...or wrote, or made music, or danced.

Every building had at least two studios under its roof, where sometimes people may not have been painting so much as always talking, arguing, debating, philosophizing, and drinking heavily (which depended more on one's purse than on one's moral state)....

I lived there for many years. It was there that I painted the first abstract picture. It was there that I mulled over "pure" painting, pure art. I tried to proceed "analytically," to discover synthetic connections, dreaming about the coming "great synthesis," feeling compelled to communicate my ideas not only to the island

surrounding me, but also to people outside this island. I regarded my thoughts as fruitful and necessary.

Thus, my fleeting notes *pro doma sua* automatically brought forth my first book *On the Spritual in Art.* Finishing it in 1910, I put it away in my drawer, since not a single publisher had the courage to risk (rather low) production costs. Nor did the very warm help of the great Hugo von Tschudi do any good.

At the same time, my wish matured to put together a book (a kind of almanac) with only artists participating as authors. I dreamt above all of painters and musicians. The harmful separation of one art from the other, of Art with a capital A from folk and children's art, from ethnography (my first enthusiasm for ethnography came much earlier: as a student at the University of Moscow I noticed, albeit quite unconsciously, that ethnography is both an art and a science. But the decisive factor was the shattering impact made on me much later by Negro art in the Museum of Anthropology in Berlin!); the solid walls between — in my eyes — so closely related, often identical phenomena, in a word: the synthetic relations, would give me no peace. Today, it may seem bizarre that for a long time I could find no collaborator, no means, simply no sufficient interest in this idea.

It was the powerful starting point of the many "isms," which did not yet know synthetic feeling and found their main interest in temperamental "civil wars." At almost the same time (1911–12), two great "currents" of painting came into the world: Cubism and Abstract (=Absolute) Painting. At the same time, Futurism, Dadaism, and the soon victorious Expressionism. Everything just steamed! Atonal music and its master Arnold Schönberg (who was hissed everywhere) aroused minds no less than the above-mentioned isms of painting.

It was around this time that I met Schönberg and instantly found in him an enthusiastic supporter of the Blue Rider idea. (At this point, it was only an exchange of letters, our personal acquaintanceship came about some time later.) I was already in touch with some future authors. It was *The Blue Rider* to-be, still without prospects of materializing. And then Franz Marc arrived from Sindelsdorf. One conversation sufficed: we understood each other perfectly. In this unforgettable man, I found an exemplar — rare at the time — and is it not as rare today? — of an artist who

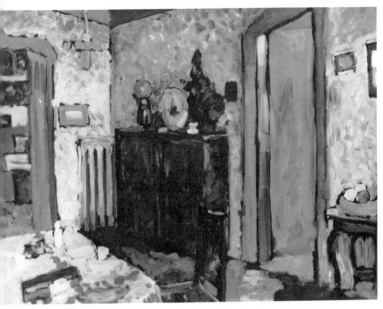

57 Vassily Kandinsky, *Interior, Living Room on Ainmillerstrasse 36.* 1909

could see way beyond the limits of "club busybodies," who was inwardly, not outwardly, against confining, inhibiting traditions.

I owe Franz Marc the publication of *The Spiritual in Art* by R. Piper: he paved the way for it. We discussed our project for long days, evenings, now and then half the night. It was perfectly clear to both of us that we had to be rigorously dictatorial: full freedom for the realization of the embodied idea.

Franz Marc brought a helpful worker in the person of a very young August Macke. We assigned him the task of mainly gathering the ethnographic material, which we also did ourselves. He did his job brilliantly and was then assigned an article on masks, which he did equally well. I took care of the Russians (painters, composers, theoreticians) and translated their articles. Marc brought a huge number of graphics from Berlin — they were

from the *Brücke,* which was only just being formed and was completely unknown in Munich.

"Artist, create, don't talk!" several artists wrote or told us, refusing our invitation to supply articles. But that belongs to the chapter on rejections, fights, and indignation, which won't be touched upon here. We were in a big hurry! Even before the appearance of the book, Franz Marc and I put on the first exhibit of the editorial board of *The Blue Rider* (We invented the name of the Blue Rider at a coffee table in the gazebo at Sindelsdorf; both of us loved blue, Marc horses and I horsemen. So the name came by itself. And Frau Maria Marc's fantastic coffee tasted even better) at the Thannhauser Gallery — the basis was the same: no propagating a specific, exclusive "direction," the adjacency of the most diverse manifestations in new painting on an international level and ...dictatorship. "...as the internal desire of the artists take shape in different ways," I wrote in the foreword.

The second (and last) exhibit was a show of graphics in the recently opened gallery of Hans Goltz, who wrote to me some two years ago, shortly before his death, with great enthusiasm about that fabulous time. My neighbor in Schwabing was Paul Klee. He was still very "small" at that time. But I can claim with justified pride that I detected the later great Klee in his very small drawings (he did not as yet paint). One of his drawings is to be found in *The Blue Rider.*

I feel a strong urge to also mention Franz Marc's exceedingly generous patron, Bernhardt Koehler, who also died recently. Without his helping hand, *The Blue Rider* would have remained a lovely Utopia, as would Herwath Walden's "The First German Autumn Salon," and a number of other things.

My next plan for the second volume of *The Blue Rider* was to place art and science next to each other: origin, development in working methods, purpose. Today I know even better than back then how many smaller roots can be traced back to one big root — the task of the future. But then the war came and washed even these modest plans away. Still, anything that is quite necessary — internally! — can be delayed but not torn out by the root.

With my very best wishes,
your Kandinsky

(from *Das Kunstblatt,* XIV, 1930, pp. 57 ff.)

Franz Marc at the coffee table in Sindelsdorf, around 1912

New Artists' Association, Munich, Membership Corporation

First exhibit. Thannhauser Modern Gallery, Munich.
1909–1910 Season. December 1–15, 1909.

Foreword:

...We start with the idea that aside from the impressions he gets from the outer world — Nature — the artist continually gathers experiences in an inner world, and the quest for artistic forms to express the mutual interaction of all these experiences — forms that must be freed of all trivia in order to express only what is necessary

59 Group portrait of artists of the Blue Rider circle. 1912
 (from left to right): Maria and Franz Marc, Bernhard Koehler Sr., Heinrich Cam-
 pendonk, Thomas von Hartmann; seated: Vassily Kandinsky

— in short, the striving for artistic synthesis — that strikes us as a watchword for rallying more and more artists spiritually....

(from the founding circular of the *New Artists' Association,* Munich)

Participating artists: Paul Baum, Vladimir von Bechtejeff, Erna Bossi, Emmi Dresler, Robert Eckert, Adolf Erbslöh, Pierre Girieud, Karl Hofer, Alexej von Jawlensky, Vassily Kandinsky, Alexander Kanoldt, Moyssey Kogan, Alfred Kubin, Gabriele Münter, Carla Pohle, Marianne von Werefkin.

New Artists' Association, Munich, Membership Corporation

Second exhibit. Thannhauser Modern Gallery, Munich, 1910/11 season. September 1– 14, 1910.

Foreword:

The work of art.

The work of art is the law that the human mind imposes upon the elements of nature, it is a relationship to them according to a specific will. *Beauty* is the feeling of this relationship and *arithmetic value* is its most universal expression.

I. The work of art viewed *constructively:*

A "numerical work of art," in constructive terms, must represent signs, and these signs are *arrangement* and *expression in general.* In the arrangement, "the number" is simple or compound. It is *simple* if a group of numerical quantities corresponds to the dimensions of the plane or pictorial distances existing between a series of points that belong together; *compound* if there is a group of original planes on the construction foundation, and if there is a group of points of view that are the results of the various direction-effects formed by the original planes. As for the values of the general expression, the number represents in imaginary terms the distances of the various points of the relief to an ideal plane

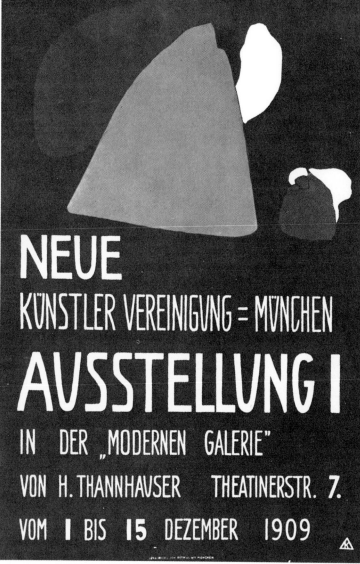

60 Poster for the New Artists' Association, Munich. 1909

running parallel to that of the picture and dividing the space into two halves in that its quality suggests that the other spatial volumes are invisible. As for the expression of tones (colors), the numbers form a scale according to the vibrations of the light. (This is essentially relative and imaginary and belongs to the area of perception.)

II. The work of art viewed *qualitatively:*

The work of art grasped numerically in this way possesses finite qualitative signs: maximum conciseness, materialization, and a certain degree of naturalism. — The maximum conciseness of means for the sake of the highest goals. (The artist creates through abstraction.) *Materialization* as the significance of the universal language of forms with the use of the most favorable means, and *the degree of naturalism* which the artist observes. Naturalism is not meant here in the sense of the naturalistic school (whose sole bias it was), but as a connection between mind and matter, retaining of the latter only what is strictly necessary in order to arouse it with the wisest moderation.

Le Fauconnier

Our art is national. At home and abroad, we young Russian artists are accused of surrendering blindly to the influence of French art.

Especially in foreign countries, we hear this reproach from superficial observers who confuse the artistic with the ethnographic and seek the national in the latter. Thus such artists as Vereshtschagin and Borissoff, who has recently been much admired abroad, are declared to be both Russian and national.

It is true that we have been taking in the universal ideas of French painting since the 1860s and are thus seemingly just a Russian reflection of this art and appear as a foreign culture, an alien soul in Russia as well. But this is only apparently the case. French art is truly kindred and comprehensible to us. The hyperbolic in line and color, the archaic, and simplification (synthesis) are all clearly present in the creative soul of our nation. Just recall our church frescoes, our popular pictures (*lubki*), icons, and finally the wonderful fairytale world of Scythian sculptures, fearful idols that are convincing in the crudeness of their form (which is nowhere else to be seen) and reveal true monumental

grandeur. Only the most ancient creations of half-primitive nations can to any extent measure up to this monumental grandeur.

This kinship of soul is the cause and reason for the infinitely enthusiastic reception, the worship of the above-mentioned French ideas of "new art" by the best Russian talents. No other country offers a similar enthusiasm in this case. And because of our spiritual kinship, these ideas became elements of our lives, and their representatives (Manet, Cézanne, Gaughin, Van Gogh, Dérain, Le Fauconnier, Matisse, Picasso) are ultimately much closer to us than the three generations of Russian artists before us, who, in the nineteenth century, were drawn to anecdotal, entertaining painting. And that is why the desirable split among artists in Russia has never been as great as today. Naturally, these ideas, by being planted, so to speak, in another soil, are by no means unchanged. The above-mentioned ancient artworks, like the country itself — the plains, rivers, meadows, people, animals, and even the sky — cannot fail to have an influence on our art.

And thus, it is not surprising that Russian artists feel strong enough not to worry about any imitation and to always remain Russian.

Dmitri Burljuk*
Vladimir Burljuk

Novaya Mayatchka
Tauris Province
(Southern Russia)

At an uncertain time, from a source that is now closed to us, yet inevitably, the work comes into the world.

Cold calculation, aimlessly jumping spots, mathematically precise construction (clearly open or hidden), silent, screaming drawing, scrupulous, thorough work, fanfares of color, their violin pianissimo, huge, calm, swaying, shattered planes.

Is that not form?

Is that not *means*?

Suffering, seeking, tormented souls with a deep gash caused by the clash between the spiritual and the material. The found. The living of live and "dead" nature. The solace in the manifestations of the world — external, internal. Inklings of joy. The calling. The speaking of secret things by secret things.

Is that not content?

*His first name was really David.

100

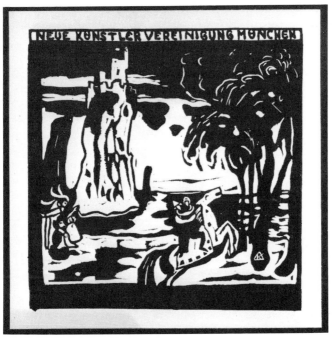

61 Vassily Kandinsky, Membership card for the New Artists' Association, Munich

Is that not the conscious or unconscious *purpose* of the compulsive creative urge?

Too bad about those who have the power to place the necessary words into the mouth of art and fail to do so. Too bad about those who turn their spiritual ear away from the mouth of art. Man speaks to man about the superhuman — the *language* of art.

Murnau (Upper Bavaria), August 1910 Kandinsky

I am addressing neither the metaphysicians nor the theoreticians, nor the pedagogues, for they do not keep their eyes persistently upon the beauties of nature. The world they live in keeps them too remote from the ideas that connect sensory impressions to thoughts. Their minds are too preoccupied with

abstraction for them to fully share and enjoy the delights of art, delights that always presuppose the relationship of the soul to real and external objects.

I am speaking to the receptive people, who, without resorting to useless interpretations, follow the secret and mysterious laws of the feelings and the soul.

Every day, the artist is subject to the unavoidable pulse beat of the surrounding world. He, as a steady midpoint of sensory impressions, is always modest, hypnotized by the miracles of nature, which he loves and analyzes, and his eyes relate constantly to the most random phenomena. After all, he strives for this union, which is so desirable to him as an artist; how could he abandon his most intrinsic condition in order, like the scholar or esthetician, to penetrate abstraction, generalization? He cannot. This activity, which lies outside him, is denied to him. Do not ask that he be a prophet. He can only yield his fruits — that is his task.

When he compares himself with others, he can only, by means of a difficult, very difficult operation, remove the glasses from his eyes and see the fruits of others clearly, without the help of their glasses. He can speak well and with deep knowledge only about himself, about his own experiences, about the specific happy or tragic lot that his destiny has bestowed on him.

As for myself, I believe I have created an expressive, evocative, undetermined art. Evocative art is the illumination of various pictorial elements brought closer together, evoking dreams which it radiates and lifts to the sphere of thought. At first, this art found no response in the public of my rationalistic generation, in which the structure of impressionism, slightly lacking in ideas, was raised. However, the present generation understands my art all the better, since everything is changing. Furthermore, youth, with its more dynamic inner life and, in France, seized more than ever by the sublime waves of music, is now inevitably open to the poems and dreams of the idealistic sculpture of this art.

July 1910 Odilon Redon

What we see here is not work that is skillfully fabricated in order to please; these are native pictures by a patient worker who loves his tools and the material he works on, and who simply tries to render, as well as possible, the truth of things that excite him. He says what he feels and the way he understands it — no more, no less — nothing to please, nothing to justify his original stimulus in terms of a preconceived "ideal." All his preparations, corrections, his entire quest has only one goal, to find the means of expression and that alone. But he always walks straight ahead, and his chief virtue is sincerity. The art of Rouault is a popular art insofar as its inspiration is sincere and naive, like that of the happy craftsman of olden times. Assuming that the common people have such an admirable store of rich sensibility, spontaneous imagination, and naive and wise humor, then these lovely gifts, which are generally misunderstood and mocked, will be more and more corrupted by mechanical work, industrial servility and the total lack of leisure, all of which characterize the modern world as does the degrading halfbaked knowledge that is so widespread today. Thus we are forced to turn back to the blissful times of the Middle Ages in order to find the full development of popular values in a completely free art. I would like to compare Rouault, who loves being a painter and ceramicist, to the workers of that period, who loved their craft with an earnest and fanatic passion and always strove to perfect themselves in their technique.

With simplicity and sincerity, they found their inspiration in the things that were presented daily to their eyes, hands, their thoughts and their wishes; I mean to say that they found all this in the faith which was their life and in the creatures they observed around them. And Rouault too finds his stimulus not in some abstract system or literary emotion, but in the things that life, the life of our time and of this land put into his hands.

But it is not only for thus seeking the motives of his inspiration in immediate reality that Rouault is similar to medieval craftsmen. Just like them, he is preoccupied with the technical means of expression; just like them, he always thinks about the material he has in his hands in order to depict things, he knows that the material makes demands, that one has to reckon with those demands, and that one masters the material only by heeding its directions. But there the similarity ends. This technical intelli-

gence is joined, in Rouault, by the whole of modern disquiet; he tries to confine reality as narrowly as possible; but he does so nervously, always improving himself anew, full of a trembling, almost raging passion. We discern the effects here of the isolation that forces every modern artist to seek his expressive means only in himself, and that deprives him of the calm given to the medieval craftsmen by dint of taking part in a large, universal work and in the same ideal.

With the toil and precision of a good worker and the restless pulse of the poetry that inspires him, Rouault spreads around us a world so real and convincing that he forces us to feel and think more deeply in the face of life.*

Participating artists:

Vladimir von Bechtejeff, Erma Bossi, Georges Braque, André Dérain, Kees van Dongen, Francisco Durio, Adolf Erbslöh, Le Fauconnier, Pierre Girieud, Hermann Haller, Bernhard Hoetger, Alexej von Jawlensky, Eugen Kahler, Vassily Kandinsky, Alexander Kanoldt, Moyssey Kogan, Alfred Kubin, Alexander Mogilewsky, Gabriele Münter, Adolf Nieder, Pablo Picasso, Georges Rouault, Edwin Scharff, Maurice de Vlaminck, Marianne von Werefkin.
Later: David Burljuk, Vladimir Burljuk, Vassily Denissoff, Eugen Kahler, Alexander Mogilewsky, Seraphim Soudbibine.

New Artists' Association, Munich
The third exhibit from 12/18/1911–January 1912, again at the Thannhauser Modern Gallery, Munich, had no foreword.

Participants in the exhibit:
Erma Barrera-Bossi, Vladimir von Bechtejeff, Adolf Erbslöh, Pierre Girieud, Alexej von Jawlensky, Alexander Kanoldt, Moyssey Kogan, Marianna von Werefkin.

*These lines are taken from the foreword to the catalog of the Rouault collection at Druet, Paris, which he has sent us.

Moderne Galerie
Heinrich Thannhauser
MÜNCHEN THEATÍNERSTR. 7

Werke erster Meister
Künstler der Secessionen
Moderne Franzosen
Der blaue Reiter

62 Exhibit in the Heinrich Thannhauser Modern Gallery, Munich

Catalog

The first exhibit of the editorial board of THE BLUE RIDER, Thannhauser Gallery, Munich. 12/18/1911–1/1/1912

In this small exhibit, we are seeking not to propagate *one* precise and special form, but rather we hope to show, in the *variety* of the forms represented, how the *inner wish* of the artist can take diverse shapes.

Participating in the exhibit:

Henri Rousseau†, Paris; A. Bloch, Munich; D. Burljuk, Moscow; V. Burljuk, Crimea; H. Campendonk, Sindelsdorf; R. Delaunay, Paris; E. Epstein, Paris; E. Kahler†, Prague; Kandinsky, Munich; A. Macke, Bonn; F. Marc, Sindelsdorf; G. Münter, Munich; J. B. Niestlé, Sindelsdorf; Arnold Schönberg, Berlin.

Leaflet with the manifesto: "The Great Upheaval...."

Subscription offering for the almanac, written by Franz Marc, mid-January 1912 (according to Lankheit: *Der Blaue Reiter,* Munich, 1965).

The Blue Rider

Art today is going along paths that our fathers would never have dreamt of; we stand in front of the new works as though in a dream and hear the Horsemen of the Apocalypse in the air; we feel an artistic tension throughout Europe — everywhere, new artists are beckoning to one another, a handshake suffices for them to understand each other!

We know that the basic ideas of what is being felt and created today existed before us, and we emphatically point out that they are not new in their *essence*; but the fact that new forms are today sprouting forth in all corners of Europe like a lovely, unexpected crop — this must be proclaimed and we must point out all the places where something new is coming into being.

†These artists are no longer living.

The awareness of this secret connection going through the new artistic production brought forth the idea of the Blue Rider. Let it be the call that rallies the artists belonging to the new age and that awakens the ears of laymen. The books of the Blue Rider will be created and piloted exclusively by artists. The first book, announced herewith, to be followed irregularly by others, encompasses the latest painting movement in France, Germany, and Russia and shows its fine connecting threads with the Gothic age and the primitives, with Africa and the great Orient, with strongly expressive and original folk art and children's art, and especially with the most modern musical movement in Europe and the new theatrical ideas of our time.

Catalog

The second exhibit of the editorial board of THE BLUE RIDER, black/white. Shown by Hans Goltz/art store, Munich/Brienner-strasse 8, 1912.

One can explain it by divine providence or by the Darwinian theory. That is not important here; the important thing is the clear working of the law.

Nature, that is to say, a world of ants or the world of stars, delights us on two sides.

One side is known to every human being: the "infinite" variety, the "unlimited" wealth of natural forms: elephant, ant, fir tree, rose, mountain, pebble.

The other side is known to the instructed: the adjustment of form to necessity (elephant trunk, ant bite).

Human beings are absorbed in the reflection of necessity in natural forms. They build zoological gardens to view the wealth of those forms. They go on trips, as far as they can — to India, Australia, to the North Pole, to delight in this variety and to keep probing the reflection of necessity, on and on.

Art is like nature in that respect: the wealth of its forms is unlimited, the variety of its forms is infinite: necessity creates these forms.

Why are some people annoyed instead of delighted when they see these natural sides of art?

Nature creates its forms for its own purpose.

Art creates its forms for its own purpose.

One should not be annoyed at the elephant's trunk, and likewise, one should not be annoyed at a form that the artist needs.

It is our ardent wish to arouse delight through examples of the inexhaustible wealth of form which the world of art indefatigably creates according to its laws.

Participants in the exhibit:

Hans Arp, Weggis; Albert Bloch, Munich; Georges Braque, Paris; Robert Delaunay, Paris; André Dérain, Paris; Maria Franck-Marc, Sindelsdorf; R. de la Fresnaye, Paris; Wilhelm Gimmi, Zurich; N. Gontscharowa, Moscow; Erich Heckel, Berlin; Walter Helbig, Weggis; Kandinsky, Munich; E. L. Kirchner, Berlin; Paul Klee, Munich; M. Larionow, Moscow; Robert Lotiron, Paris; Oscar Lüthy, Weggis; August Macke, Bonn; K. Malevich, Moscow; Franz Marc, Sindelsdorf; W. Morgner, Soest; Otto Mueller, Berlin; G. Münter, Munich; Emil Nolde, Berlin; Max Pechstein, Berlin; Pablo Picasso, Paris; Russian folk pictures; Georg Tappert, Berlin; Paul Vera, Paris; Maurice Vlaminck, Paris; Alfred Kubin, Wernstein; Moriz Melzer, Berlin.

The Blue Rider

Foreword to the second edition, 1914

More than two years have passed since the publication of this book. One of our goals — in my eyes the chief goal — has not quite been attained. This goal was to show by means of examples, practical arrangements, and theoretical evidence that the issue of form in art is a secondary one, that the question of art is mainly a question of content.

63 Publishing Announcement for *The Blue Rider*, R. Piper & Co., Munich. 1912

In practice, the Blue Rider has proved to be right: what has come about formally has died. It has lived — allegedly lived — barely two years. What has come about out of necessity has "developed" further. Because of the hastiness of our age, the more comprehensible has formed "schools." Thus the movement reflected here has generally broadened, and at the same time it has gotten more compact. The explosions initially necessary for the breakthrough are thus waning — in favor of a calmer, stronger, broader, more compact torrent.

This spread of the spiritual movement, and, on the other hand, its powerfully concentric whirlwind strength which keeps violently pulling new elements to itself, is the sign of its natural destination and its natural goal.

And thus life, reality, go their own way. These thundering characteristics of the great age inexplicably go unheard: the public (which includes many art theoreticians), in contrast to the spiritual striving of the time, continues more than ever to observe, to analyze, to systematize the formal element exclusively. — Thus the time may not yet be ripe for "hearing" and "seeing."

But the justified hope that that time will come is also rooted in necessity.

And this hope is the most important reason for the republication of *The Blue Rider*.

At the same time, the future has come closer to us in individual cases during these past two years. Thus, greater precision and evaluation have become more possible. Further things will grow organically out of the universal. This growth and the now especially clear connection of individual, once seemingly quite separate areas of intellectual and spiritual life, their mutual coming together, in part their mutual interpenetration, and the resulting blended and hence richer forms, constitute the necessity to further develop the ideas of this book, which point to a new publication.

K[andinsky]

"Anything that develops can only be started on earth."

This statement by Däubler can be placed above all we create and desire. A fulfillment will come, sooner or later, in a new world, in another existence. On earth, we can only sound the theme. This first book is the prelude to a new theme. Its jerky, nervous fashion has probably revealed to the attentive listener the purpose for which it was conceived. The listener found himself in a source area in which there is a mysterious throbbing in a hundred different places at once, a now hidden, now open singing and murmuring. We walked with the divining rod through the art of the ages and of the present. We showed only the living, untouched by the constraint of convention. Everything that is born out of itself in art, living out of itself and not walking on crutches of habit — that was the object of our devoted love. Wherever we found a crevice in the crust of

64 Franz Marc, *Legendary Animal.* 1912. This woodcut, hand-painted and signed by the artist, was added to the de luxe edition of *The Blue Rider* almanac (Munich, 1912)

convention, we pointed it out; only there, since we hoped that underneath there would be a force that would one day come to light. Some of these cracks have closed up again since then — our hope was futile; from others, however, a live source is already gushing forth. But this is not the only meaning of this book. The great solace of history has always been that nature constantly pushes new energy through all depleted refuse; if we saw our task only in the act of pointing to the natural springtime of a new generation, we could readily leave this to the sure passage of time; there would be no cause to evoke the spirit of a great new era with our calls.

We oppose great centuries with a "no." We are quite aware that this simple "no" will not break the earnest and methodical course of the sciences and of triumphant "progress." Nor do we intend to hurry ahead of this development; instead, amid the mocking amazement of the people around us, we are taking a side road, which scarcely seems to be a path, and we say: This is the main

highway of human development. We know that today the main crowd cannot follow us; they find the path too steep and untrodden. But the fact that today some people already want to go along with us — that has been taught to us by this first book, which we now release once again in the same form, while we ourselves have detached ourselves from it and are involved in new work. We don't know when we will gather for the second book. Perhaps when we find ourselves all alone again; when modernity has stopped trying to industrialize the jungle of new ideas. Before the second book is realized, a great deal must be sloughed off and perhaps torn violently away — things that have attached themselves to the movement in these years. We know that everything can be destroyed if the beginnings of an intellectual and spiritual discipline are not preserved against the greed and impurity of the crowd. We are struggling for pure thoughts, for a world in which pure thoughts can be thought and spoken without becoming impure. Only then shall we or those more qualified than we be able to show the other face of Janus' head, which is still concealed and turned away from the times today.

How we admire the disciples of early Christianity for finding the strength for internal silence amid the clamorous noise of that time. We plead every hour for this silence and strive for it.

March 1914 F[ranz] M[arc]

Preface to the Planned Second Book

One more time and many times more, the attempt will be made to turn the gaze of yearning man from the good and beautiful seeming of the legacy of the old age, to dreadful, roaring Being.

When the leaders of the crowd point right, we go left; when they point to a goal, we turn back; if they warn against something, we hurry toward it.

The world is filled to suffocating. Man has placed a token of his wisdom on every stone. Every word is leased and mortgaged. What

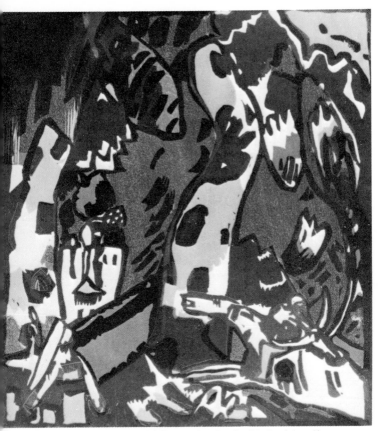

5 Vassily Kandinsky, *Archer*. 1908/09. This woodcut, hand-painted and signed by the artist, was added to the de luxe edition of *The Blue Rider* almanac (Munich, 1912)

can one do for bliss but to abandon everything and flee, draw a line between yesterday and today?

This deed is the great mission of our time; the only one worth living and dying for. This deed has nothing of scorn for the great past. But we want something different; we do not want to live like happy heirs, to live on the past. And even if we did want to, we would be unable to do so. The legacy has been consumed; surrogates make the world common.

Thus we wander off into new areas and experience the great shock that everything is still untrodden, unsaid, unfurrowed and uninvestigated. The world lies pure before us; our steps tremble. If we dare to walk, the navel cord tying us to the maternal past must be severed.

The world is bearing a new time; there is only one question: Has the time now come to cut loose from the old world? Are we ripe for the *vita nuova*? That is the anxious question of our day. It is the question that shall dominate this book. What is written in this book relates only to this question and serves no other. Its shape and its value are to be measured by that question.

(February 1914) Fz. Marc

(from Lankheit: *Der Blaue Reiter*, Munich, 1965)

DER
BLAUE REITER

Inhalt der ersten Nummer.

66 Handwritten table of contents of *The Blue Rider* almanac

Konstruktion in der Malerei Kandinsky.

Reproduktionen.

Ausgrabungen von Benin, Ägyptische Schattenspiele, Siamesische Schattenspiele, Negerkunst, Kinder= zeichnungen, Gotische Kunstwerke, Bayrische Glasmalereien, u. Votivbilder, Russische Volksblätter und Plastik u. s. w. Moderne Kunst: W. Burljuk, R. Delaunay, LeFauconnier, Gauguin, Giriend, Cézanne, Kandinsky, Koboschka, Marc, Matisse, Münter, Jawlensky, Picasso, Werefkin u. s. w.

Table of Contents of the Almanac

Quotations From *The Blue Rider*

For we have the consciousness that our world of ideas is no house of cards that we are playing with, but contains elements of a new movement whose vibrations can be felt throughout the world today.

...Cézanne and El Greco are of congenial minds beyond the separating centuries...their works stand today at the entrance to a new epoch of painting. Both felt, in the picture of the world, the *mystical, internal* construction which is the great problem of today's generation.

(from "Spiritual Goods" by Franz Marc)

...People understood that art is concerned with the deepest things, that the renewal must not be formal, but a rebirth of thinking.

Mysticism awakened in souls and with it ancient elements of art.

It is impossible to explain these last few works of the "Fauves" in terms of formal development and reinterpretation of impressionism....The most beautiful prismatic colors and famous Cubism have become meaningless as goals to these "Fauves."

Their thinking has a different goal: through their work they want to create *symbols* for their time, symbols that belong on the altars of the coming spiritual religion....

(from "The 'Fauves' of Germany" by Franz Marc)

The first works of a new time are infinitely hard to define — who can clearly see what they aim at and what is to come? But the very fact that they *exist* at all and are produced in many places that are often quite independent of one another and are of an inner truth makes it certain that they are the first signs of the coming new epoch....

(from "Two Paintings" by Franz Marc)

Ungraspable ideas are expressed in graspable forms....Form is a mystery for us because it is the utterance of mysterious forces. It is only through form that we have an inkling of the secret forces, the "invisible God."

...Creating forms means: living. Are children not creative beings who draw directly from the mystery of their feelings more than the imitator of Grecian form? Are the "Fauves" not artists who have their own forms, as powerful as the form of thunder?...Like man, his forms also change.

The relationship of the many forms to one another allows us to recognize the individual form. Blue becomes visible only through red, the largeness of the tree through the smallness of the butterfly, the youth of the child through the age of the old man. One and two makes three. The formless, the infinite, the zero remain ungraspable. God remains ungraspable.

Man expresses his life in forms. Every art form is an utterance of man's inner life. The outerness of the art form is its innerness.

(from "Masks" by August Macke)

What is Cubism?

First and foremost, it is the conscious will to restore the knowledge of dimension, volume, and weight in painting.

Instead of Impressionist spatial illusion, which is based on aerial perspective and color naturalism, Cubism offers simple, abstract forms in certain relationships and proportions to one another....The first postulate of Cubism is thus the order of things; not naturalistic things, however, but abstract forms. It feels space as a compound of lines, spatial units, square and cubic equations and balance relationships.

It is the artist's task to put an artistic order into this mathematical chaos. The artist wants to arouse the latent rhythm of this chaos.

(from "Characteristics of Renewal in Painting" by Roger Allard)

Present-day art, which, in these terms, can correctly be designated as anarchistic, not only mirrors the already conquered

spiritual standpoint, it also embodies, as a materializing power, the spiritual ripened to the point of revelation.

The forms of embodiment, wrested by the mind from the storeroom of matter, can easily be placed between two poles.

These two poles are:

1. great abstraction
2. great realism

These two poles open up *two roads,* which ultimately lead to *one goal*....

Great realism...only just budding, is an effort to drive the external artistic element out of painting and to embody the content of the work by means of a simple ("unartistic") rendering of the plain, hard object. The object's outer shell, grasped in this way and fixed in the painting, and the simultaneous canceling of familiar, importunate beauty, most surely lay bare the inner sound of the thing. It is precisely through this shell, with this reduction of the "artistic" to a minimum, that the soul of the object resounds most powerfully.

The minimized "artistic element" must be recognized here as the most strongly effective abstract.

The great contrast to this realism is the great abstraction, which consists of the striving to seemingly leave out altogether the objective (the real), and to embody the content of the work in "non-material" forms. The abstract life, thus grasped and fixed in the painting, of objective forms reduced to a minimum and thus to the conspicuous predominance of abstract entities, most surely lays bare the inner sound of the painting....

The "understanding" of this kind of painting requires the same freedom as in realism, i.e. here too it must be possible to hear the whole world as it is, without objective interpretation. And here these abstracted or abstract forms (lines, planes, spots, etc.) are not in themselves important as such; only their inner sound is important, their life....

The "objective," reduced to a minimum, must be recognized as the most powerfully operating reality in abstraction....

The greatest difference in the exterior becomes the greatest similarity in the interior.

(from "On the Question of Form" by Kandinsky)

Form is always temporal, i.e. relative, since it is nothing more than the means necessary today, in which today's revelation manifests itself, sounds.

Sound is thus the soul of form, which can only come alive through sound and *operates* from inside to outside.

Form is the outer expression of the inner content.

That is why we should not turn form into a deity. And we should not struggle for form any longer than it can serve as a means of expressing the inner sound. Hence we should not seek salvation in *one* single form....

Since form is merely an expression of content, and content is different for different artists, it is clear that *many different forms that are equally good can exist at the same time.*

Necessity creates form....

Thus form mirrors the mind of the individual artist. Form bears the stamp of his *personality.*

And thus, as a final conclusion, we have to establish: the most important thing is not whether form is personal, national, in good style, whether it is in line with the main contemporary trend or not, whether it is akin to many or few other forms or not, whether it is altogether isolated or not, etc., etc.; the *most important thing in the question of form is whether form has grown from inner necessity or not.*

(from "On the Question of Form" by Kandinsky)

The Theses of Free Music

...Free music goes by the same laws of nature as music and the whole art of nature.

The artist of free music, like the nightingale, is not limited by notes and half-notes. He also uses fourth- and eighth-notes and music with a free selection of notes....

The Advantage of Free Music

New enjoyment of the unfamiliar assembling of notes.
New harmonies with new chords.

New dissonances with new resolutions.

New melodies.

The selection of possible chords and melodies is extraordinarily broadened.

The power of musical lyricism is increased, and that is the main thing, because music is mainly lyricism. Free music offers a greater possibility to affect the listener and evoke spiritual excitement in him.

...The study and use of colorful music are made easier.

...The close unification of notes evokes very unusual sensations in people.

...Close unification also creates musical pictures which consist of special planes of color that melt into running harmony, similar to new painting.

(from "Free Music" by N. Kulbin)

Every art has its own language, i.e. the means intrinsic to it alone.

Thus every art is self-contained. Every art has a life of its own. It is a realm unto itself.

That is why the means of different arts are externally altogether different. Sound, color, word!...

At bottom, *the ultimate, internal bottom,* these means are completely the same: the ultimate goal wipes out the external differences and lays bare the internal identity.

(from "On Stage Composition" by Kandinsky)

Quotations From: *On the Spiritual in Art* by Vassily Kandinsky

(quoted from the R. Piper & Co. second edition, Munich, 1912)

Foreword to the first edition

The ideas I am developing here are the results of observations and emotional experiences that have gradually accumulated during

the last five or six years. I wanted to write a major book on this theme, for which many experiments in the area of emotions would have to be made. Absorbed in other, equally important works, I had to forgo my original plan for the time being. Perhaps I will never be able to carry it out. Someone else will do it better and more exhaustively, since it is a necessary task. I am thus compelled to remain within the limits of a simple scheme and make do with pointing out the great problem. I will consider myself fortunate if this pointing-out does not fade into nothingness.

Foreword to the second edition

This little book was written in the year 1910. Before the publication of the first edition (January 1912), I inserted further experiences of the interim time. Since then another six months have passed, and today I see certain things more clearly, with a wider horizon. After careful deliberation, I have decided not to add anything, since it would only and unequally make some parts more precise. I have decided instead to add the new material to sharply defined observations and experiences that I have been accumulating for several years now and that may, in time, as individual parts of a kind of *Harmony Theory of Painting* form a continuation of this book....A fragment of the further development (or supplement) is my article "On the Question of Form" in *The Blue Rider*.

Munich, April 1912 Kandinsky

67 Egyptian shadow-play figure.
Reproduced in *The Blue Rider* almanac (where it was reproduced in color)

123

There is a crack in our souls, and when one manages to touch the soul, it sounds like a precious vase that has been found again in the depths of the earth and has a crack. That is why the primitive trend that we are now experiencing in today's rather borrowed form can only be of brief duration. (p. 5)

An artist who sees no goal for himself in the artistic imitation of natural phenomena and is a creator who wants and has to express his *inner* world, enviously sees how such goals can be naturally and easily attained in the most non-material art today — music. He understandably will turn to it and try to find the same means in his own art. Hence today's quest in painting for rhythm, for mathematical, abstract construction, the present-day appreciation of the repetition of color tones, of the way in which color is set into motion, etc. (p. 37)

Painting today is almost completely dependent on natural forms, forms borrowed from nature. And its task today is to test its strength and means, to get to know them, such as music has been doing for a long time, and to try to apply these means and strength in a purely painterly fashion for the purpose of creation. (pp. 38/39)

The more freely the abstract lies in form, the more purely and thereby more primitively it sounds. Thus in a composition in which the physical aspect is more or less superfluous, one can also more or less omit this physical aspect and replace it with physical bodily forms that are purely abstract or completely translated into abstract terms. In every case of this translation or this composition of purely abstract form, the sole judge, pilot, and guide should be emotion. And of course the more the artist needs these abstracted or abstract forms, the more at home he will be in their realm and the deeper he will enter into this territory. (pp. 60 ff.)

This is the only way to express what is mystically necessary.
All means are sacred if they are inwardly necessary.
All means are sinful if they do not come from the source of inner necessity. (p. 69)

The artist must have something to say, since his task is not the mastery of form, but the adjustment of this form to content. (p. 118)

Something is beautiful if it springs from an inner spiritual necessity. Something is beautiful if it is inwardly beautiful. (p. 119)

The accompanying six reproductions are examples of constructive strivings in painting.

The forms of these strivings fall into two main groups:

1. simple composition, which is subordinated to a simple form that clearly comes to the fore. I call this composition *melodic;*

2. complicated composition, which consists of several forms subordinated to a clear or veiled main form. This main form can be very hard to find externally, so that the inner basis receives an especially powerful sound. I call this complicated composition *symphonic.*

...If one removes the objective from melodic composition, thereby laying bare the fundamental painterly form, one finds primitive geometric forms or the presence of simple lines serving a general movement....All these constructive forms have a simple inner sound, which every melody has too....

As examples of the new symphonic compositions, in which the melodic element is used only occasionally and as one of the subordinate parts, though it receives a new shape, I have added three reproductions of my own paintings.

These reproductions are examples of three different original sources:

1. the direct influence of "outer nature," which is expressed in a graphic, painterly form. I call these pictures *"Impressions";*

2. chiefly unconscious, mostly sudden expressions of events of an inner character, hence impressions of "inner nature." I call this kind *"Improvisations."*

3. expressions forming within me in a similar way (but extremely slowly), which are tested and worked out by me for a long time and almost pedantically after the first drafts. I call this kind of painting a *"Composition."* Here reason, the conscious, the intentional, the purposeful play a dominant role. Except that emotion, and not calculation, is always given the prerogative. (pp. 121 ff.)

Selected Bibliography

Der Blaue Reiter
Ed. by Vassily Kandinsky and Franz Marc, Munich, 1912. Second edition, 1914. New documentary edition by Klaus Lankheit, Munich, 1965.

Wingler, Hans Maria: *Der Blaue Reiter*. Feldafing, 1954.

Buchheim, Lothar Günther: *Der Blaue Reiter und die "Neue Künstlervereinigung München."* Feldafing, 1959.

Gollek, Rosel: *Der Blaue Reiter im Lembachhaus München*. Munich, 1974 (with a list of exhibition catalogs).

Important catalogs and articles:

Munich, Haus der Kunst: *Der Blaue Reiter: München und die Kunst des 20. Jahrhunderts 1908-1914,* 1949.

Der Blaue Reiter, Wegbereiter und Zeitgenossen. Catalog of the Basel Kunsthalle, 1950.

Grohmann, Will: "The Blue Rider," in: Bernier, G. and M.: *The Selective Eye.* New York, Reynal, 1956.

Thwaites, John Anthony: "The Blaue Reiter, a Milestone in Europe" in: *The Art Quarterly* 13, 1956.

General literature:

Roh, Franz: *Die Kunst des 20. Jahrhunderts,* Munich, 1946.

Schmidt, Paul Ferdinand: *Geschichte der modernen Malerei.* Stuttgart, 1952

Grote, Ludwig: *Deutsche Kunst im 20. Jahrhundert.* Munich, 1954 (second edition)

Haftmann, Werner: *Malerei im 20. Jahrhundert.* Munich, 1954

Myers, B. S.: *Die Malerei des Expressionismus,* Cologne, 1957

Röthel, Hans Konrad: *Moderne deutsche Malerei.* Wiesbaden, 1957

Roh, Franz: *Geschichte der deutschen Kunst von 1900 bis zur Gegenwart.* Munich, 1958

Schmidt, Georg: *Die Malerei in Deutschland 1900-1918,* Königstein, 1966

Richter, Horst: *Malerei unseres Jahrhunderts.* Cologne, 1969

Vogt, Paul: *Geschichte der deutschen Malerei im 20. Jahrhundert.* Cologne, 1972

List of Reproductions

Black-and-White Illustrations

1 Photo of Franz Marc around 1913

2 Vassily Kandinsky in Munich, 1913

3 Ernst Ludwig Kirchner: *Fränzi in front of Carved Chair*. 1910
 Oil on canvas, 70.5 x 50 cm
 Thyssen-Bornemisza Collection, Lugano-Castagnola

4 Emil Nolde: *In the Café*. 1911
 Oil on canvas, 73 x 89 cm
 Folkwang Museum, Essen

5 Erich Heckel: *Saxon Village*. 1910
 Oil on canvas, 70 x 82 cm
 Museum von der Heydt, Wuppertal

6 Ernst Ludwig Kirchner: *The Painters of the Brücke,* 1925
 (from left to right: Mueller, Kirchner, Schmidt-Rottluff, Heckel)
 Pen and ink and wash, 48 x 36.5 cm
 Württemberg, Staatsgalerie, Stuttgart (graphics collection)

7 Fritz Erler: *Horses by the Brook*. No date
 Oil on wood, 140 x 69.5 cm
 Städtische Galerie in the Lenbach House, Munich

8 Adolf Hoelzel: *Landscape with Birches*. 1902
 Oil on canvas, 39 x 49 cm
 Mittelrheinisches Landesmuseum, Mayence

9 Adolf Hoelzel: *Belgian Motif*. ca. 1908-10
 Oil on canvas, 84 x 67.3 cm
 Museum Folkwang, Essen

10 Vassily Kandinsky: *Outside the City*. 1908
 Oil on cardboard, 68.8 x 49 cm
 Städtische Galerie in the Lenbach House, Munich

11 Vassily Kandinsky: *Bright Air*. 1902
 Oil on canvas, 34 x 52 cm
 Private collection, Paris

12 Vassily Kandinsky: *Old Town* (Rothenburg on the Tauber). 1902
 Oil on canvas, 52 x 78.5 cm
 Private collection, Paris

13 Vassily Kandinsky: *Colorful Life*. 1907
 Tempera on canvas, 130 x 162.5 cm
 Städtische Galerie in the Lenbach House, Munich

14 Vassily Kandinsky: *Upper Bavarian Small Town (Murnau)*. 1909
 Oil on canvas, 71.5 x 97.5 cm
 Kunstmuseum, Düsseldorf

15 Poster for the first Phalanx exhibit, 1901
 Color lithograph after a drawing by Kandinsky, 52 x 67 cm

16 Vassily Kandinsky: *First Abstract Water Color*. 1910
 Water color, 49 x 65 cm
 Private collection

17 Gabriele Münter: *Portrait of Marianne Werefkin*. 1909
 Oil on painting cardboard, 81 x 55 cm
 Städtische Galerie in the Lenbach House, Munich

18 Alexej von Jawlensky: *Self-Portrait with Top Hat*. 1904, no. 3
 Oil on canvas, 57 x 47 cm
 Wiesbaden Museum

19 Vladimir von Bechtejeff: *Horse Tamers*. ca. 1912
 Oil on canvas, 100 x 94 cm
 Städtische Galerie in the Lenbach House, Munich

20 Adolf Erbslöh: *Upper Bavarian Mountain Landscape near Brannenburg*.
 No date.
 Oil on cardboard, 69.5 x 99.5
 Staatliche Kunsthalle, Karlsruhe

21 Vassily Kandinsky: *Portrait of Gabriele Münter*. 1905

Oil on canvas, 45 x 45 cm
Städtische Galerie in the Lenbach House, Munich

22 August Macke, 1913. Photograph

23 Gabriele Münter: *Man at Table* (Kandinsky). 1911
Oil on painting cardboard, 51.6 x 68.5 cm
Städtische Galerie in the Lenbach House, Munich

24 Gabriele Münter: *Village Street in Winter*. 1911
Oil on painting cardboard, 52.4 x 69 cm
Städtische Galerie in the Lenbach House, Munich

25 Vassily Kandinsky: *Horseman Jumping over Hurdle*. 1910
Oil on cardboard, 71 x 71 cm
Private collection

26 Vassily Kandinsky, *Composition V*. 1911
Oil on canvas, 190 x 250 cm
Private collection
(rejected for the third exhibit of the *New Artists' Association*.)

27 August Macke: *Portrait of Franz Marc*. 1910
Oil on cardboard, 50 x 38 cm
Staatliche Museen Preuss. Kulturbesitz, Nationalgalerie, Berlin

28 Vassily Kandinsky: Title woodcut for the catalog of the First
Exhibit. 1911

29 Vassily Kandinsky: *On the Spiritual in Art*. Munich, 1911

30–33 Vassily Kandinsky: Sketches for the jacket of *The Blue Rider* al-
manac, 1911
Water color and India ink wash over pencil, all around 28 x 22 cm
Städtische Galerie in the Lenbach House, Munich

34 Paul Klee: *Stonecutters*. 1910 (no. 74)
Pen and India ink and wash, dimensions and location unknown
Reproduced in *The Blue Rider* almanac

35 Alfred Kubin: *The Fisherman*. 1911/12
Pen drawing on old cadastral paper, 22.5 x 14.8 cm (picture), 31 x
18.2 cm (size of paper)
Private collection, Karlsruhe
Reproduced in *The Blue Rider* almanac

36 Egyptian shadow-play figure
 Reproduced in *The Blue Rider* almanac

37 Japanese drawing
 Reproduced in *The Blue Rider* almanac

38 Arnold Schönberg: *Self-portrait*. 1911
 Oil on cardboard, 49 x 43.5 cm
 Collection of Mrs. Gertrud Schönberg, Los Angeles
 Reproduced in *The Blue Rider* almanac

39 Franz Marc: *The Bull*. 1911
 Oil on canvas, 101 x 135 cm
 The Solomon R. Guggenheim Museum, New York

40 Vassily Kandinsky: *Impression 2* (Moscow). 1911, 114
 Oil on canvas, 120 x 140 cm
 Formerly in the collection of Bernhard Koehler, Berlin (destroyed by fire)

41 Robert Delaunay: *St. Séverin*. 1909
 Oil on canvas, 116 x 81 cm
 Private collection, Zurich
 Reproduced in *The Blue Rider* almanac

42 Robert Delaunay: *The Town*. 1911
 Oil on canvas, 145 x 112 cm
 The Solomon R. Guggenheim Museum, New York

43 Franz Marc: *Grazing Horses IV (The Red Horses)*. 1911
 Oil on canvas, 121 x 183 cm
 Private collection, Rome

44 Franz Marc: *Resting Horses*. 1913
 Water color, 10.7 x 18.4
 Private collection, Stuttgart

45 Franz Marc: *Sleeping Shepherdess*. 1912
 Woodcut, 19.8 x 24.1 cm

46 Vassily Kandinsky: *Composition II*. 1911
 Woodcut, 14.9 x 21 cm

47 Vassily Kandinsky: *Improvisation 9*. 1910
 Oil on canvas, 110 x 110 cm
 Private collection

48 Vassily Kandinsky: Water color for "Study of Painting with White Edge." 1913
 Water color with India ink wash, 37.8 x 27.5 cm
 Städtische Galerie in the Lenbach House, Munich

49 Vassily Kandinsky: *Small Joys,* no. 174. 1913
 Oil on canvas, 105.5 x 120 cm
 The Solomon R. Guggenheim Museum, New York

50 Franz Marc: *The First Animals.* 1913
 Tempera, 39 x 46.5 cm
 The Solomon R. Guggenheim Museum, New York

51 Franz Marc: *Wild Boar and Sow.* 1913
 Oil on cardboard, 74 x 58 cm
 Wallraf-Richartz Museum and Ludwig Museum, Cologne

52 Franz Marc: *Saint Julian.* 1913
 Tempera, 63 x 58 cm
 The Solomon R. Guggenheim Museum, New York

53 Franz Marc: *Animal Destinies (The Trees Show Their Rings, the Animals Their Veins).* 1913
 Oil on canvas, 196 x 266 cm
 Kunstmuseum, Basel

54 August Macke: *Large, Bright Shop Window.* 1912
 Oil on canvas, 105 x 85 cm
 Niedersächsische Landesgalerie, Hannover

55 Vassily Kandinsky: Mural for Campbell. 1914 (summer)
 Oil on canvas, 162.5 x 92.1 cm
 The Museum of Modern Art, New York (Mrs. Simon Guggenheim Fund, 1954)

56 Franz Marc: *Playing Forms.* 1914
 Oil on canvas, 56.5 x 170 cm
 Folkwang Museum, Essen

57 Vassily Kandinsky: *Interior, Living Room on Ainmillerstrasse 36.* 1909
 Oil on cardboard, 50 x 65 cm
 Städtische Galerie in the Lenbach House, Munich

58 Franz Marc at the coffee table in Sindelsdorf around 1912. Photo

59 Group portrait of artists of the Blue Rider circle. 1912

(from left to right): Maria and Franz Marc, Bernhard Koehler Sr., Heinrich Campendonk, Thomas von Hartmann; seated: Vassily Kandinsky
Photograph

60 Poster for the *New Artists' Association.* 1909

61 Vassily Kandinsky: Membership card for the *New Artists' Association,* Munich
Felsen, 1908/09
Woodcut, 12.3 x 14.4 cm

62 Exhibit in the Heinrich Thannhauser Modern Gallery, Munich

63 Publishing announcement for *The Blue Rider,* R. Piper & Co., Munich. 1912

64 Franz Marc: *Legendary Animal.* 1912
Woodcut, hand-painted and signed by the artist; this picture was added to the de luxe edition of *The Blue Rider* almanac (Munich 1912)

65 Vassily Kandinsky: *Archer.* 1908/09
Woodcut, hand-painted and signed by the artist; this picture was added to the de luxe edition of *The Blue Rider* almanac (Munich 1912)

66 Handwritten table of contents of *The Blue Rider* almanac.
From the estate of August Macke, October 1911

67 Egyptian shadow-play figure.
Reproduced in *The Blue Rider* almanac (where it was reproduced in color)

List of Color Plates

9 Vassily Kandinsky: *Lyrical*. 1911
 Oil on canvas, 94 x 130 cm
 Boymans-van Beuningen Museum, Rotterdam
 Reproduced in *The Blue Rider* almanac

10 Robert Delaunay: *Eiffel Tower*. 1910/11
 Oil on canvas, 130 x 97 cm
 Folkwang Museum, Essen

11 Robert Delaunay: *Discs: Sun no. 1*. 1912/13
 Oil on canvas, 100 x 81 cm
 Wilhelm Hack collection, Cologne

12 Franz Marc: *Cats, Red and White*. 1912
 Oil on canvas, 52 x 35 cm
 Private collection, Switzerland

13 Franz Marc: *Dead Doe*. 1913
 Water color, 16.3 x 13 cm
 Frau Etta Stangl, Munich

14 Vassily Kandinsky: *Landscape with Church I*. 1913
 Oil on canvas, 78 x 100 cm
 Folkwang Museum, Essen

15 Vassily Kandinsky: Water color. 1913
 Private collection

16 August Macke: *Lady in Green Jacket*. 1913
 Oil on canvas, 44 x 43 cm
 Wallraf-Richartz Museum and Ludwig Museum, Cologne

17 August Macke: *Market in Tunis I*. 1914
 Water color, 29 x 22.5 cm
 Private collection

18 Franz Marc: *The Poor Land of Tyrol*. 1913
 Oil on canvas, 131.5 x 200 cm
 The Solomon R. Guggenheim Museum, New York

19 Franz Marc: *Battling Forms*. 1914
 Oil on canvas, 91 x 131.5 cm
 Bavarian State Painting Collections, Munich

20 Franz Marc: *Does in the Forest II*. 1914
 Oil on canvas, 110.5 x 100.5 cm
 Staatliche Kunsthalle, Karlsruhe

Photographic Credits

Walter Dräyer, Zurich. Ill. 26
The Solomon R. Guggenheim Museum, New York. Ill. 39, 42, 49, 50, 52
Landesbildstelle, Stuttgart. Ill. 44
Archiv Klaus Lankheit, Karlsruhe. Ill. 59, 64
Mittelrheinisches Landesmuseum, Mayence. Ill. 8
André Morain, Paris. Ill. 11, 12
The Museum of Modern Art, New York (Mrs. Simon Guggenheim Fund)
 Ill. 55
Neues Museum, Gemäldegalerie, Wiesbaden. Ill. 18
Niedersächsische Landesgalerie, Hannover. Ill. 54
R. Nohr, Munich. Ill. 56
Öffentliche Kunstsammlung, Basel. Ill. 53
Rheinisches Bildarchiv, Cologne. Ill. 51
Saarland-Museum, Saarbrücken. Plate 7
Schmölz-Huth, Cologne. Ill. 4, 5, 14
Staatliche Kunsthalle, Karlsruhe. Ill. 20
Städtische Galerie in the Lenbach House, Munich. Frontispiece, Ill. 7, 10
 15, 17, 19, 21, 23, 24, 30-33, 47, 48, 57, 65
L. Witzel, Essen. Ill 9

All the other photos and plates come from the archives of DuMont
 Publishers, Cologne.